PSL Guide to
Available Light Photography

Don O. Thorpe

Patrick Stephens Ltd.
Cambridge, England

Note: In the appendix of this book you will find a table for converting U.S. Customary measurements to the metric system. You will also find a table for ASA and DIN equivalents.

All photos in this book were taken by the author unless otherwise credited.

Chart on page 53 from an article in New Era originated by Don O. Thorpe, copyright 1977 by New Era; reprinted by permission.

Published in Great Britain by Patrick Stephens Limited

British Library Cataloguing in Publication Data

Thorpe, Don O.
 PSL guide to available light photography.—(PSL photo guides).

 1. Photography, Available light
 I. Title II. Guide to available light photography III. Series

778.7 TR147

ISBN: 0 85059 406 5 (Softbound)

ISBN: 0 85059 405 7 (Hardbound)

Manufactured in the United States of America

10 9 8 7 6 5 4 3 2 1

OTHER BOOKS IN THE PSL GUIDE SERIES

Available now

To be published

Dedication

I dedicate this book to my wife and my mother, the two great women in my life: the one helping me to begin the photographic quest, the other supporting my freelance spirit.

Acknowledgements

Many thanks to George Allen, Royce Bair (of PhotoUnique), Harold Excel and Jim Peeler (of Inkley's Photo), Lonnie Lonczyna, and Jack Thomas for their assistance and encouragement. But most of all, a warm expression of gratitude goes to my wife for her wholehearted help—sorting, cataloguing, proofreading—and for her special gift of unfailing devotion to me and dedication to the completion of this book.

I would also like to acknowledge that some of my photographs used in this book first appeared in publications of the Deseret Book Company and Young House Publishers, and in the *New Era* and *Ensign* magazines. Much of Chapter 6 was published as an article in *New Era* under the title, "Photographic Exposure Made Easy."

Foreword

By John Lewis Stage

For a photographer, there is a very special joy in meeting an author, in person or through his writings, whom you instinctively know has experienced the same wonder, and magic, and sometimes frustration of your kind of photography. Immediately this new person becomes an old friend; he is a kindred spirit, with common passions; a fellow veteran of photographic battles. He speaks your language. He shares your aspirations to photographic expertise.

Such was my reaction to Don O. Thorpe, an obviously talented and accomplished professional, who in the following pages writes simply and directly and with great practical know-how about one of his passions, low-light photography.

His enthusiasm is contagious. He is both a realist and an idealist. He writes about techniques, but his eye is always on the final finish. His standards are high, technically and philosophically, and, fortunately for us, he is a natural teacher endowed with a desire to share his knowledge.

There are two particular beauties in low-light photography: the soft, rich, and subtly color-saturated beauty of the photographic image itself, and, just as important, the beauty of truth and believability that is inherent in the use of available light. Like other men of spirit, Thorpe is a seeker of this truth. He has found that the ability to photograph under low-light conditions is essential to attaining this high-minded goal. So he has thought about it, experimented, tested, and developed techniques that point the way to success time after time. He describes them in this book, and we all stand to gain by his words.

5

Under conditions of low light, the photographer is operating at the extreme limits of sensitivity of film and of lens. It is not an area for the safe, the timid, or the impatient photographer. In this subtle and shadowy world you risk possible failure in an effort to gain visual rewards that are far beyond the triteness of "perfect sharpness and even lighting."

This kind of photography requires head and heart, as well as hands. This is not the world of the automatic camera and thoughtless snapshots, it is a higher level of photography; and to profit most from this important book you should be prepared to think, to feel, and to work. I suggest you use this as a work guide: Use your camera, test every Thorpe suggestion, take your time, be honest about your results, and, if need be, do it again. At each step you will learn, you will gain experience, competence, and discretion. Thorpe will guide you. His experience will save you endless time and effort. But in essence photography is a self-teaching process; that is part of its charm, its satisfaction, and its magic. Good Luck.

Contents

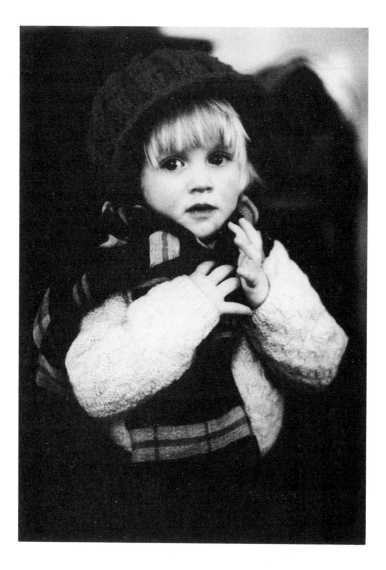

1

The Usefulness of Low-Light Photography

The term "low-light photography" applies to a situation of natural or artificial existing light in which the level of brightness is low, making ordinary photographic techniques difficult to use or entirely inadequate.

What that really means is this: It is tough to make good photographs when the available light is low. It takes special skills to get quality results when dim light makes seeing, focusing, and steadying a camera awkward, not to mention deciding on exposure.

Special skills are necessary but are really not difficult to learn and use. Anyone can get great photos in low light with the camera and film he or she generally uses. Each chapter in this book will be devoted to a useful skill or attitude that will help you get those will-o'-the-wisp low-light photographs.

In a sense, low-light photography can be considered a special kind of photography, not necessarily because of subject matter or philosophy, but because of its extension of the reach of photography. It's something like driving a car at night: the darkness forces you to be more alert and precise. I have noticed, during the times that I have driven from night into day, that my senses are much keener in the daylight after an all-night drive than they usually are. This leads me to believe that the alertness of the senses carries

9

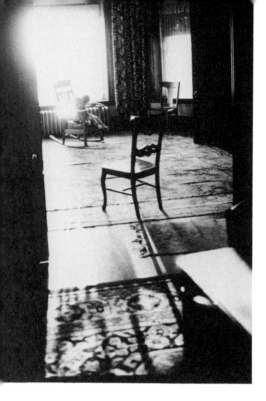

over from one to the other. In the same way, the skills learned for low-light conditions will also improve your other photography by making you more sensitive to the variables of light and of emotion.

BENEFITS OF LOW-LIGHT CONDITIONS

Low light is usually associated with natural and relaxed surroundings. Photography in these conditions has an air of authenticity you seldom find anywhere else. After all, you are photographing people as they really are in their normal environment, away from the glare of revealing bright lights and daylight.

◄ Late afternoon sunlight adds backlight drama to an Idaho farm-house preserved from the turn of the century. Exposure decided by "reading" the rug with camera's built-in averaging meter. Tri-X film rated at ASA 800; 35 mm lens; Nikkormat camera.

Aunt Stella was photographed in her southern Utah home by light from a window beside the piano. Behind-the-lens meter reading, plus half-stop overexposure, on Tri-X film rated at ASA 800. 35 mm lens on Nikon F camera.

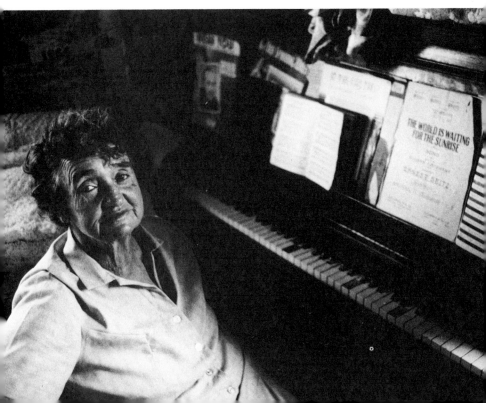

The gentleness of softly lit rooms, dusky evenings, and darkened streets creates the impressionistic moods that many strive for in creative photography. The shared love of a young couple watching television together in their living room, an old man sitting under his favorite cottonwood tree in the early evening, or one of your favorite aunts sitting at an old upright piano, talking about the good old days—these are the kinds of natural subjects you will find in the realm of low-light photography.

Most of the time these situations arise when you least expect them. Leaving to get a flash unit or extra lighting equipment would destroy the mood and stiffen the subject.

I like to sit with friends and relatives and photograph them as we talk together. It seems easier to slip into

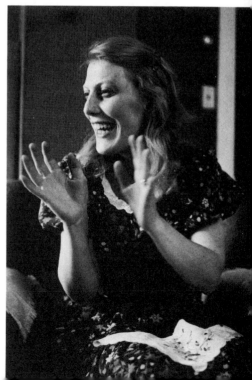

Sidelighting outlines the hands, emphasizing the gesture which animates the picture. A "grab" shot by window light, taken on Tri-X at ASA 800; 50 mm lens; Nikkormat camera.

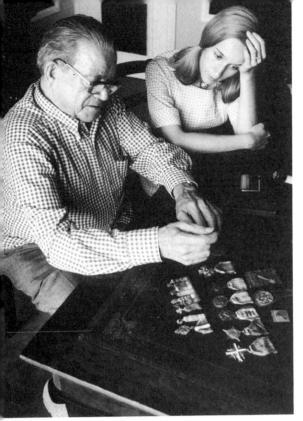

Grandpére recounts aviation adventures in two world wars. Window light catches the medals, the proud hands displaying them, and the face of the onlooker, reinforcing the picture's storytelling values. Ilford HP4 film. Incident-light-meter reading of light falling on medals. Olympus OM-2 camera.

Diffused window light, free of harsh shadows, adds to a quiet mood. Room lamps throw some light into shadowed areas; also, half-stop exposure was given beyond reading by behind-the-lens meter. Tri-X at ASA 800; 85 mm lens; Olympus OM-2 camera.

13

photographing them as a natural consequence of our conversation if I make the photography part of the experience—as unnoticeable as possible. This means being ready to shoot without a lot of accessories and bright lights. Use of artificial lights, sometimes even room lights, almost always destroys the warm relationships of these encounters.

People tend to pay less attention to you as a photographer, and more attention to you as a person, in low-light conditions. Without flash or bright lights you are more likely to blend into the surroundings. Bulky equipment and other paraphernalia tend to distract or annoy a subject.

But the main advantage of using only the ambient light is that it encourages and preserves the natural feelings.

Visually, low-light effects can be exciting. The lighting varies from a soft, kind light to light that creates dramatic shadows and stark silhouettes. Low light seems to possess a special magic that can transform common objects into impressionistic images.

Take a walk with your camera and look around your neighborhood in the late afternoon or early evening when the light is low. You will see how ordinary things are turned into fantasy subjects.

2

Equipment and Attitudes

The main intention of this chapter is to convince you never to pass up a photographic opportunity because you lack what you feel is the right equipment. Many of my best photos have been taken without benefit of the "right" lens or film.

Some years ago, I was sitting on the front porch of a relative's home when across the street I saw a young child walking along trailing a large ribbon behind her. For a short, rare moment I was seeing childhood's carefree but lonely world. Luckily I had my camera with me—I had just finished shooting some close-ups with a 50 mm lens attached to my 35 mm single-lens reflex camera.

The shot really needed a telephoto lens, but there just wasn't enough time to change lenses because the child and the moment would be gone in an instant. Hurriedly I grabbed a quick shot, hoping to focus and compose carefully on the next one. However, the little girl disappeared from my sight behind some parked cars, and the magical moment was gone.

The negative is slightly thin—underexposed—and I have to print from a very small section of the negative to get the image I want, but the picture says what I felt about childhood at that moment. It is, to this day, one of my favorite photographs. If I had talked myself into waiting to shoot with a telephoto lens, I would have missed it.

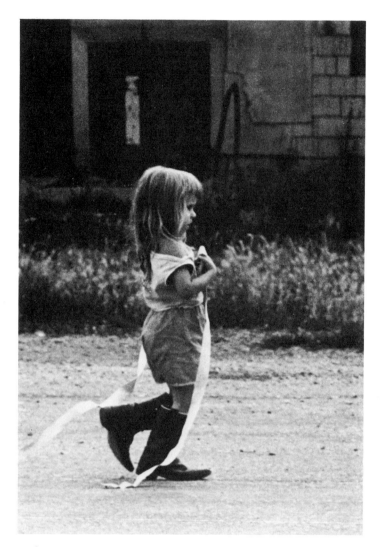

Stay constantly alert to pictures that are going to happen. This little girl almost got away (see preceding page). Plus-X film; 50 mm lens; Nikon F camera.

Make do with what you have. If you can do it again better later with other equipment, do so; but for that present moment, give it your best effort with what you have at hand.

BASIC EQUIPMENT

All you really need is an adjustable camera loaded with medium-to-fast film. Of course, there are some accessories that will make life a little easier when the existing, or available, light is dim. For instance, a tripod can be indispensable when extremely slow shutter speeds are needed. A cable release is a must and takes virtually no room to carry.

Sometimes an extra piece of equipment, such as a tripod, can slow you down or discourage you from photographing because of the time it takes to get it out and set it up. Extra equipment also gets in your way if you are trying to move quickly. The less you have weighing you down the better.

One of the reasons for the popularity of the new compact 35 mm cameras is their light weight. Those who have ever stumbled around all day with a heavy camera and a bagful of accessories find this development a blessing. What a relief it is to stroll along with a bantamweight camera around your neck and not a care in the world.

Some of the best professionals can be seen at important events photographing with a single camera and lens. They know the worth of being free and easy in tense situations. Leaving extra cameras and lenses behind gives them more mobility and concentration power. The psychological effect is worth the loss in optics. When you are free from discomfort and awkward bulk, your attitude can be more creative and spontaneous.

Don't get me wrong, there is a place for extra lenses and equipment in photography. When I'm on location assignment I pack everything but my copy stand and polarized lights—and, on some occasions, have taken them, as well. But low-light available-light photography is a special thing; spontaneity is the key, and quick shooting is the way. So don't slow yourself down with unnecessary equipment.

LENSES

The best all-around low-light lens is a 50 mm $f/1.4$ lens. This superfast little gem will permit you to photograph in extremely low light. The perspective and angle of view of the 50 mm lens—standard for most 35 mm cameras—are very near to what the eye sees. The camera's "normal" lens is also free from the distortions that can characterize pictures taken with a wide-angle lens.

So don't look with disdain on the 50 mm lens that may have come with your camera. It may not seem as sophisticated or have the distinction of super-wide-angle and telephoto lenses, but it makes possible an uncluttered and consistent form of photography and allows you to get the shots you might otherwise miss while switching lenses. One of the great photojournalists of all time, Henri Cartier-Bresson, uses a 50 mm lens almost exclusively.

If you feel lost without some variations in focal lengths, consider taking just two lenses—an 85 mm lens, $f/2$ or faster, and a 35 mm or 28 mm lens, $f/2$ or faster. These two lenses will give you a wide range of visual alternatives. Moving slightly closer or farther away will drastically change your field of view with a wide-angle lens, and the telephoto lens will allow extreme close-ups of faces and details.

If your telephoto or wide-angle lens is slower than $f/2$, you would be better off taking along a fast little 50 mm

A long lens caught this natural expression without interrupting the child's mood. Normal room lighting; Tri-X film, overexposed half a stop from the reading by the in-camera meter; 85 mm lens on Contax RTS camera body.

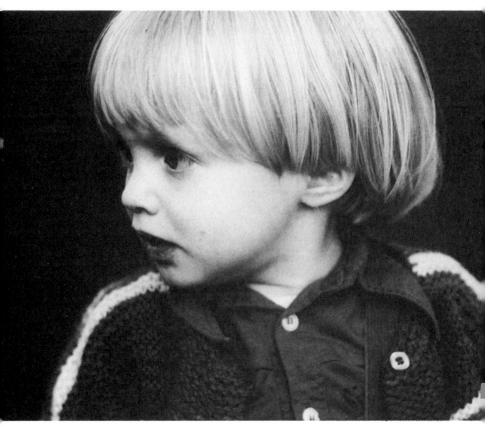

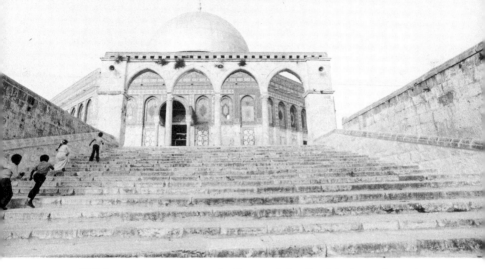

Children race up steps to the Dome of the Rock in Jerusalem. A 21 mm wide-angle lens provided the depth of focus that makes this kind of photograph work. Tri-X film was used under overcast skies; incident-light meter determined exposure. Olympus OM-1 camera.

$f/1.4$ lens, too. That extra stop or two of speed can be a lifesaver.

A fast telephoto lens helps you get closer to the subject visually, without crowding, and usually can give you a lens speed fast enough for you to hand-hold the shot. Another advantage of the telephoto lens is its ability to throw background objects out of focus and so separate the subject from a busy background.

A wide-angle lens extends perspective, giving a "bigger" look to small places. It can also allow slower shutter speeds without apparent camera movement. Generally, you can use a shutter speed one step slower with a wide-angle lens than with a 50 mm "normal" lens.

Remember that the reverse is true of a telephoto lens—you should use the next-faster shutter speed than when using the 50 mm lens.

A good rule of thumb is to convert your lens's focal length into a fraction and consider that to be the slowest shutter speed it is wise to hold in your hand without a tripod. For example, the slowest speed to use with a 35 mm

lens should be 1/30 sec.; with a 100 mm lens, the shutter speed should be 1/125 sec. or faster. (Chapter 4 will give you some new limits to think about.)

AN EXTRA BODY

An extra camera body will let you keep two lenses mounted and ready. This allows for rapid shooting and will put you on top of most fast-moving action scenes. Some of the best news photographers work in this manner. Using two bodies and the lenses mentioned earlier, you have fast control of a wide range of distances, viewpoints, and composition.

Just be aware, again, that an extra camera will call attention to you as a photographer and perhaps limit your ability to blend into the natural surroundings. Depending on your personality and on the circumstances, this may or may not be a problem.

CAMERA STRAPS

Two cameras hung around your neck can create havoc with each other and with your chest, especially in fast-moving situations. They tend to bang together, and one or the other tends to get in the way when you try shots from any unusual angles.

There are several ways to solve this dilemma. One is to hang one camera on a very short strap and the second on a longer strap, so that the two can dangle on your chest without touching each other. A second solution is to hang one camera from the neck in front and the other diagonally over the shoulder so that it rests on a hip.

I find that nylon straps about 19 mm (¾ inch) wide work best. They are quite comfortable, and the nylon material slides easily on coats, collars, and necks. You can actually drop the shoulder-hung camera and it will slide

Above: *Two cameras can be hung in front if you leave enough space between them so they do not bang together.*

Facing page, top: *Having one camera hung to the side and one in front keeps both handy in fast-moving situations.*

Facing page, bottom: *An easily adjustable 19 mm (¾ in.) strap, such as the one shown here, is described in the text.*

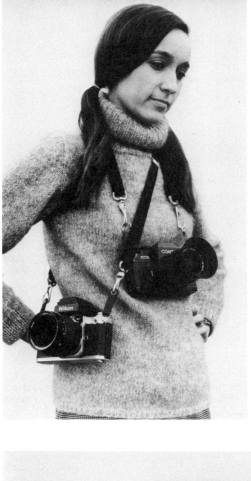

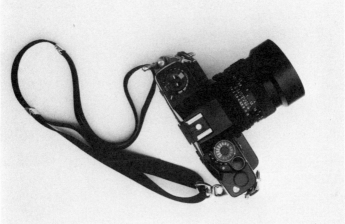

23

silently and smoothly onto your hip and out of the way while you are getting ready to shoot with the other camera. The straps I use are all the same length and have continuously variable settings, so that one standard length can be adjusted to fit any arrangement.

With intelligent and creative use of some very basic equipment, you can get photographs that will surprise you. Most of the equipment you will need is probably stashed away in your camera bag, waiting to be used. Use a tripod if you want to, or substitute some other support (as shown in Chapter 4). Use a telephoto or a wide-angle lens if it is instantly available; if not, shoot anyway. And remember, your most important pieces of "equipment" are your head and your heart.

3

Being Ready

The essence of good creative photography is the spontaneous moment. This is even more important in the natural, flowing conditions of low-light photography. The fleeting, passing parade of everyday life does not slow down or wait for photographers to *get* ready—they must *be* ready.

Sure, you can build up to the moment of truth by careful preparation of mind and equipment; but don't fumble the ball, because no one will wait for you to pick it up and start the game again. Become ready for the fleeting moments you want to capture on film by preparing yourself and your equipment far in advance of the action.

HOW TO BE READY

There are lots of little things you can do easily to get ready—things that do not take much effort or skill but that can make a great deal of difference in your ability to get the photographs you want.

First, prepare your camera in advance for the most likely photographic conditions. Attach the lens that will be the most useful in that situation. You would be amazed at the number of photographers who wait until the last mo-

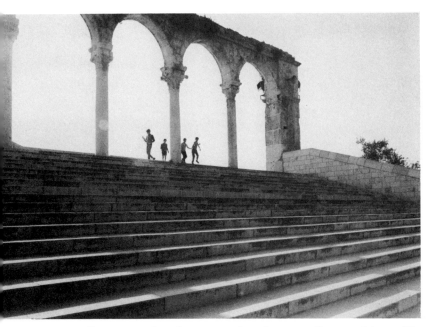

To capture these boys at peak action, a reading was taken with behind-the-lens averaging meter (on Olympus OM-2 camera), then Plus-X film was rated at ASA 200 to create slight under-exposure that would silhouette the boys. (Taken at Dome of the Rock, Jerusalem).

ment to put on the lens they know is going to be needed. Try to anticipate *before* the photo opportunity arises all the equipment you will need.

Preset your *f*/stops and shutter speeds to match the light intensity and expected motion. Take periodic light readings in advance of—not during—the shooting action. Keep checking the meter settings so that your camera is current to the conditions.

Prefocus your lens to the approximate distance from which you will be shooting. Use the depth-of-field scale on the lens barrel to see how much distance you can cover without having to refocus. This may be the only way you will get a shot at a quickly moving subject that you know is coming in a certain direction.

This may seem minor, but it is not. Hold your camera in readiness, with your hands in position to shoot instantly. It is possible to shoot an extremely quick grab shot with one hand holding the camera, if you make a practice of keeping your right hand in position to shoot while at the same time gripping or holding the camera body. This can be useful if you are busy keeping your balance or warding off pressing human bodies with the other arm.

Get into the habit of shooting first, then carefully composing, focusing, checking light readings, and shooting again. If you have done the proper preparation, chances are the first grab shot will be exposed and focused correctly—and many times, that is the only shot you will get. Many would-have-been-great pictures are lost because the photographer is not ready to shoot, or to shoot instantly.

Being ready to shoot is mainly a question of attitude. It is the ability to recognize quickly the possibility of a photograph, and then to transmit that idea into instantaneous action—without hesitation or question. Not that you should shoot photographs without integrity. My feelings on that topic could fill another book. Photographers, whether amateur or professional, should first consider

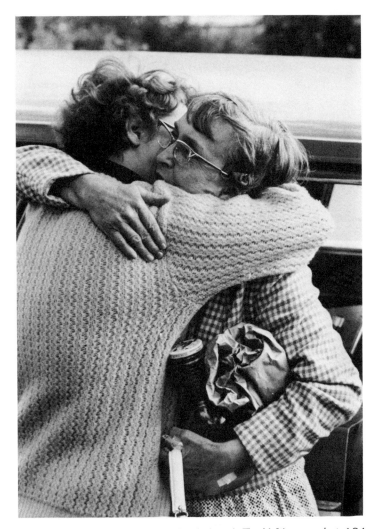

The author had his camera loaded with Tri-X film rated at ASA 800, preset for the lighting conditions and an average distance, when this touching scene occurred. He was able to "grab" the mother-daughter farewell without hesitation.

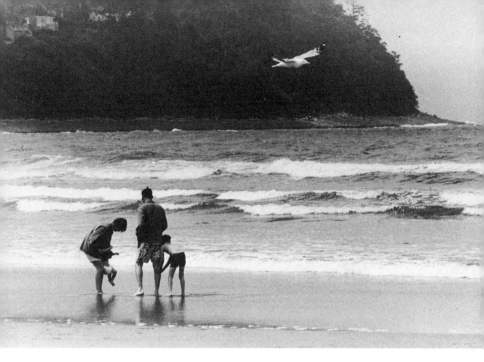

Above: *A passing bird balances the scene. Timing like this comes from being ready—and lucky. Shot in Oregon using a Nikon F with 200 mm telephoto lens; Plus-X film rated at ASA 200 because of dull, overcast light. Exposure was one stop more than meter reading.* Below: *The light was perfect for rim-lighting, where highlights determine exposure (see Chap. 6). Tri-X film; Nikon F.*

themselves as human beings with responsibility for the well-being of others. As reporters on humanity and interpreters of our fellow beings, we have a stewardship of the highest order. It is entrusted to us to be kind and considerate in the use of photographic skills.

When I say, "don't hesitate," I mean, don't wait for a better position or try to conserve film, or wait for the "best" shot. Undoubtedly more great shots are missed because of hesitation than because of any other one fault. Another villain is the I'll-shoot-it-later syndrome. The mood of the moment, the lighting, the object itself will never really be the same again. If nothing else changes, your feelings will, and you will produce a totally different kind of photograph.

So do it now! Get by with what you have and the circumstances as they are. Improve them if you can; but shoot first and ask questions later.

4

Keeping Your Camera Steady

Some amazing things can be done with today's small cameras, especially the compact 35 mm variety. They are versatile and easy to use, and can still produce pictures of excellent quality. But they are also a little finicky at times. You must use some care and precision or your photographs will disappoint you. This is especially true when you take your camera into situations where the level of existing light is low.

Most of the time low available light forces you to use slow shutter speeds. Anything below 1/60 sec. usually allows camera movement during exposure; and an unsteady camera makes blurred photographs. The solution is to find ways to hold your camera steady when using these slow shutter speeds.

THE STEADY CAMERA GRIP

If you use this camera grip properly, you should be able to hand-hold at shutter speeds of 1/8 sec. or slower. That is comparable to handling three to four f-stops less light. Here's how it works.

First, pick up your camera with your right hand, making sure that the right side of the camera is firmly rest-

31

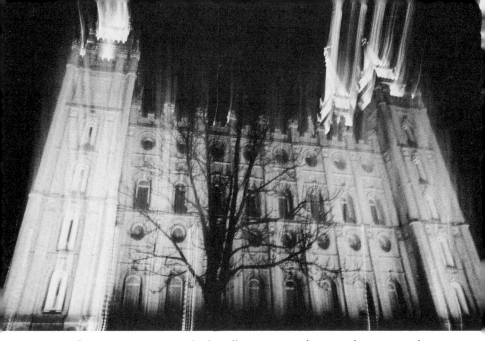

Camera movement, which will ruin most photographs, was used here on purpose to create a feeling of celestial elevation in this picture of the Mormon temple in Salt Lake City. The camera was held still at first, then moved during the last part of the ½ sec. guessed-at exposure.

ing against the palm. Now place your left hand, palm up, under the lens and wrap your fingers around the lens barrel (see accompanying photo). This grip will almost automatically force you into the next step. Bring your arms close together across your chest and sides, being sure they touch as much of your body as possible. Now press the camera against your face, making it touch as much of your face as possible. There should be contact with your cheek, eye area, and nose. The closer the camera fits against the face, the better.

This basic camera grip is used in standing, sitting, and kneeling positions, and can be used with the elbows resting on something solid, such as a table, or as you lean against a wall or the like.

32

Above: *For a steady camera grip, keep elbows close to the body and hands close together.* Right: *The camera can be braced on a chair back or similar support for rock-steady shooting.*

Most of the time, you will be using this grip when you are standing in the open with nothing to support you. During these times, take care to plant your feet in a comfortable stance and as firmly as the terrain permits. Just before shooting, take a deep breath, exhale slowly about half-way, hold your breath, and gently squeeze the shutter release.

If this sounds vaguely familiar, you may have had experience shooting a rifle. A camera is much like a rifle—they both need to be aimed accurately and held steady. A rifleman uses anything available to steady the rifle; you should do the same thing with your camera.

Another trick borrowed from the rifleman is the use of the strap for added support. A tight strap will hold the camera firmly against your face and keep camera movement to a minimum.

Facing page, far left: *Use your elbows on a table to turn yourself into a tripod to brace the camera.* Facing page, right: *Leaning against a wall is another way to steady your shooting.* At left: *Loop the strap around your hands near the wrist, then press against the strap, forcing the camera against your face to keep it from moving. Other grips for fast-action shooting are shown in the next chapter.*

USE YOUR STRAP

Pick up your camera as you did before, but this time put your hands on the inside of the strap before you take hold of the camera (see accompanying photo). Now force the strap outward and forward with both hands so that the camera is pulled into your face by the tight strap. The strap must be quite short to accomplish this, so it is best to have one of adjustable length. Widths of about 13 mm (½ inch) to 19 mm (¾ inch) seem to work best. The superwide straps that are now popular tend to be awkward.

THE TABLETOP, OR MINITRIPOD

An extremely useful camera-steadying accessory is the tabletop tripod. I have used this miracle gadget in

desert sands and freezing snow, and in crowded Parisian cafés. It is so small and lightweight you can always take it with you. Slip it into a pocket, hang your camera around your neck, and away you can go—unrestricted and unnoticed.

The best way to use this minitripod is to "stand" it on your chest as a support when hand-holding the camera (see accompanying photos). With some practice you can probably extend your hand-held shutter speeds to an amazing 1/2 sec.! All the techniques mentioned in the section about steady camera grips apply here, as well.

The minitripod-on-the-chest arrangement gives you all the mobility of a hand-held camera but adds the stability of a tripod. You will be surprised at how this can extend photographic possibilities.

Further, you can use the minitripod as you would a regular tripod for those extra-long timed exposures. Just

Facing page, far left: *A tabletop tripod is useful both indoors and out. Indoors, remove the camera's strap.* Facing page, right: *Press it against a solid wall for time exposures. Notice the usefully long cable release.* Above: *Pull the camera toward you with equal pressure on your face and on your chest or shoulder when using a minitripod as a chest-pod.*

stand it on a table, a bench, a wall, or the ground. Of course, you will need a cable release for exposures longer than 1/2 sec.

If you need a high angle of view you can even brace the minitripod against a vertical surface, but be sure to hold the legs tightly against the surface (see accompanying photo).

THE CLAMP-POD

This camera-supporting device uses a "C"-clamp arrangement instead of legs. It can be clamped to chair backs, fence railings, and the like. It can even be used like the minitripod when clamped to a book or a board (see accompanying photo). Its rubber or felt pads protect furni-

Above left: *A clamp-pod attached to a chair back or the like can stand in for a large tripod.* Above right: *A book and a clamp-pod can form a minitripod nearly as stable as that shown on Page 36.*

ture from scratches and marks, although I wouldn't clamp it onto someone's priceless antique Chippendale chair.

A BEAN BAG?

A recent innovation for camera support comes from the toy box in the form of a bean bag. These handy little bags can be molded and kneaded to hold a camera in a wide variety of positions. All you have to do is set your camera on top of the bean bag and form the bag to hold the camera where you want it. You can press the bag into double duty by using it as a cushioning partition between lenses, etc. As a bonus, it can be used to distract kids while you shoot their natural expressions.

Above: *A bean bag can be molded to support the camera in a variety of positions. (The camera's neck strap has been removed).* Right: *A shoe can brace the camera at different angles, too, if you have no bean bag or sandbag.*

USE YOUR SHOE

You have left everything at home except your camera. Don't despair; take off a shoe and get on with it. Actually, a shoe has variously shaped and angled surfaces upon which you can lean the camera. Use the camera's self-timer to activate slow shutter speeds (up to one second on most cameras) if you did not bring a cable release, either.

Obviously, all these gadgets are only stand-ins for the old trusty tripod. But they do have some advantages over the tripod, in that they are lightweight and small. If weight and size (and mobility) do not matter, take along the tripod.

39

FOLLOW THROUGH

All these moves are useless unless you remember to follow through, like a good golfer. Get in the habit of squeezing the shutter release smoothly and continuously, and don't take the camera away from your eye until a second or so after the picture has been taken. With some experimenting and practice, you will begin producing much sharper photographs. This will happen partly because of your increased ability to hold a camera steady, but mostly because of the self-confidence you will have developed from discovering that ability—and also learning its limits.

5

Better Ways To Focus

It is surprising to find how many differences exist among individuals when it comes to the ability to focus a camera. There is a wide range of visual abilities in people: One person is farsighted while another is nearsighted, and so forth. It is not surprising, then, that some of us have trouble getting sharply focused photographs. But even if the effects of all eye problems could be corrected with eyeglasses or with corrective eyepieces on cameras, there still would be many blurry, out-of-focus photographs.

Most of the blurriness results from poor focusing techniques rather than from poor eyesight. Under the pressure of rapidly changing circumstances, many photographers tend to focus quickly on the center of a subject and shoot. Or they focus in front of or behind the mark.

Modern cameras have many and varied means of helping the photographer focus accurately. Some have a split image in the viewfinder, others use the microprism spot method, and still others have two images that must be aligned. Some combine two or more systems. The trouble with all these devices is that they rely on sharply defined images to work properly. Many times subjects are not sharply defined. Besides, the average photographer does not look for sharp images in the scene; he or she looks at the subject while focusing. You will need to train yourself

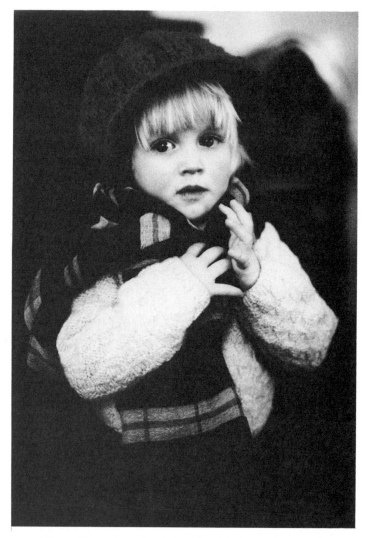

The patterned scarf and the blond hair were used as focusing points because they are easy to see in dim light. Tri-X film; 85 mm lens; Contax RTS camera.

Sidelighting on these fence posts provides separation and contrast, thus both helping the photographer to focus under dim light and enhancing the final image.

to look at the subject in a new way, and to use other techniques of focusing.

LOOK FOR CONTRAST AND HARD EDGES

Areas of sharp contrast, where dark and light portions of the subject come together, make excellent aiming points because they are easier to see as they pop in and out of focus (see illustration). The same is true of straight edges. Look for a contrasty or hard-edged area in a landscape scene, an area in the same plane (at the same distance from the camera) as the subject you want to show in

focus, and focus on that. When shooting a group of people, look for the edges of collars, shirt fronts, or coat lapels. With only one face, focus on the eye nearest you or on the edge of a nose that is turned to the side. A patterned object on or near the subject also makes a good reference point (see the picture at the beginning of this chapter). The pattern makes it easy to see any slight out-of-focus condition that might be overlooked.

When you find the contrasty area or sharp edge in the scene, place the focusing aid in your viewfinder over that area so that it is cut in half, or bisected. Then, carefully move your camera's distance adjustment until the area looks perfectly clear and sharp. It sometimes helps to rack the lens focusing ring back and forth to zero in on the area.

If you are trying to focus on a horizontal line with a horizontal-split-image rangefinder, turn the camera sideways to bisect the line. Sometimes turning the camera diagonally or rocking your whole body back and forth will let you compare the sharpness at various camera positions.

In normal daylight or under bright artificial light these specialized techniques are not usually necessary. But when you get into dim light you may need to use several techniques to make sure of accurate focus.

Each focusing method has its good points and its bad points. You have to determine for yourself which works best with your camera and with your particular way of seeing. Experiment with all the techniques. Take photographs and compare the results with a magnifying glass. Then you will know for sure which is best for you.

USING THE DEPTH-OF-FIELD SCALE

There are several situations where a depth-of-field scale can help when the existing light level is low. For in-

stance, you might not be able to see a focusing aim point because of extremely low light or very diffuse subject matter. Or you might need to shoot a subject that appears and disappears very quickly without giving you enough time to focus.

A depth-of-field scale tells the nearest and farthest distances that will be in focus at each aperture setting. To understand how this works, compare the depth-of-field scale to a driver's-license eye examination. If a person is too nearsighted or too farsighted a license will not be issued to that individual; but between these extremes there is quite a range of acceptable visual ability.

The depth-of-field scale shows the range within which the image will look sharp. This can change with

The depth-of-field scale on this lens is between the rings controlling the f-stops (bottom) and the distance (top). The lens is set at f/8 and focused at 25 ft (7.6 m). Pointers from the "8" repeated at each side of the center line show that this setting of this lens will give sharp images from 12 ft (3.6 m) to infinity.

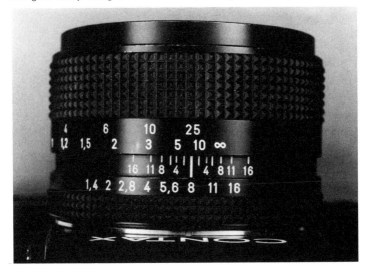

This focusing grip supports the camera while allowing quick changes in aim. Hold the camera in the palm of the left hand; turn focusing ring with the fingertips. The hand that trips the shutter carries no weight.

each *f*-stop and each lens. For instance, a 50 mm lens mounted on a 35 mm camera and focused at 1.3 m (4 feet) will produce an acceptably sharp image of a subject as near as 90 cm (3 feet) or as far away as 1.8 m (6 feet) when closed down to *f*/16. When the focus is changed to the 15-foot mark, the range is greater—from about 2.4 m (8 feet) to about 31 m (nearly 126 feet). That is, the lens's depth-of-field scale shows the range of acceptable sharpness at each *f*-stop when that lens is focused at a specific distance.

To use the scale, measure or guess the distance from the camera position to the subject; then find on your lens the marker for that distance (see accompanying photo). Move that marker until it is opposite the *central* pointer mark on the lens barrel. Now find out the range (or "depth of field," or "zone of sharp focus") that this setting permits by reading off the distance measurements opposite the pair of similar *f*-stop numbers—one on each end of the scale. These tell you how much margin of error you will

This vertical grip lets the camera be handled entirely at one end, so the photographer's arms can be braced against the body for extra support (also see Chapter 4).

have for achieving acceptable sharpness in the given photographic situation.

As you observe these settings and the relationship of distances and f-stops, you will see that the distances in front of and behind the subject are not equal. In the setting mentioned earlier, acceptable sharpness would be achieved within the area of 30.5 cm (1 foot) in front of the focus point and 61 cm (2 feet) behind it. Keeping the same camera position, you could give yourself an extra 2 feet of depth behind the subject by changing the point of focus: By changing the focus point to 1.5 m (5 feet), you would increase the range of sharpness from 1.1 m (3½ feet) to 2.4 m (8 feet). Thus, by sacrificing 15 cm (6 inches) on the near side you could gain 61 cm (2 feet) extra on the far side.

You can use the depth-of-field scale in another way: to determine the focus point of a subject on which you cannot focus. Find two reasonably well-defined objects—one in front of and one behind the desired focus point—

that can be used as focusing objectives. Focus on them, or estimate the distance to them, and set the lens's focus point to an intermediate position between them.

A final note on depth-of-field scales: Each manufacturer of lenses has its own way of showing depth of field on the lens. Most of them put the numbers representing the f-stop to the right and left of the center of the lens so that you can see at a glance the distance between these two numbers—this is the depth-of-field measurement.

It is a good practice to carry a small flashlight or penlight, so that you can always see the numbers that indicate the depth-of-field, as well as the f-stop and the shutter speed.

FOCUSING GRIP

How you hold the camera while focusing can make the difference between smooth control and erratic action. Cradle the camera in the palm of your left hand (see illustration), letting your fingers curl around the lens barrel. Turn the focusing ring with your fingers only, not with your wrist. Using this grip, you will not move the camera unnecessarily. You will also be able to shoot while actually in the process of focusing—a real advantage when trying to cover a fast-moving subject. With a little practice, you can develop the ability to focus and shoot in a single motion.

Some manufacturers have the focusing ring rotate clockwise and some, counterclockwise. You should practice with your camera until you know instinctively which way to turn the ring to focus nearer or farther. This could mean the difference between getting the photograph and not getting it.

6

Exposure Without Pain

Probably the worst villain in photographic failure is poor exposure. A washed-out, colorless slide or print, or even slightly overexposed areas in an otherwise normal-looking slide, can ruin a shot. Dark, muddy colors and lack of visual texture and detail are characteristics of the underexposed photograph. Such problems are magnified under low light.

Take this imaginary example: You have been shooting an important ball game and you have been looking for a dramatic image to add to the usual running and kicking pictures. Long shadows from the stands cover the field, creating dark patterns as the team huddles for the final play of the game. The score is tied, and excitement is high.

The players shift slightly; suddenly their yellow uniforms are ablaze with color from a small patch of sunlight near the edge of the field. Everything else is in deep shadow. You center the exposure needle carefully and manage to squeeze off one shot just before the team moves back into the shade of the scrimmage position. What a shot—the bright yellow uniforms set off by the contrast of dark shadow.

You send the film to be processed and cross your fingers. A few days later the slides come back, and you nervously look for that great shot. There it is! But something is

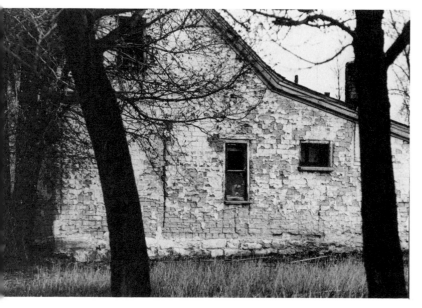

Under an overcast sky, a reflected-light reading from the grass indicated just the right exposure to give this house of adobe brick a texture you can almost feel, while the foreground trees have gone nearly black. Plus-X film; Nikon F camera.

wrong. Instead of showing the blazing color you saw at the game, the yellow uniforms are almost colorless. That great image was not captured. What happened?

To understand what really went wrong, you need to know how the common exposure meter works. An exposure meter is merely an instrument that is sensitive to light. Its needle moves in relation to the amount of light that strikes its photosensitive cells. Some meters measure all the light falling on a subject (incident-light meters). Others (reflectance meters) "read" all the light reflected from the

smaller area of *brightly lit* subject will be overexposed; hence, the colorless helmets.

There are several methods of solving this kind of exposure problem. One method is to move in close and take a reading just from the main subject, then use that setting for the entire picture area. An alternative method for a distant subject is to take a reading from a nearby object similar to the main subject in tonal value (lightness or darkness) and lighting.

But what if the entire subject is very dark—or extremely light? If you use the exposure given by the meter, you will get grayed blacks or grayed highlights, respectively, because, as explained above, the meter averages the whole scene to middle gray.

THE ZONE SYSTEM

The answer to this dilemma is something called the *zone system of exposure.* You can use the extremely simplified version offered here and still get accurate exposure. The zone system allows you to compensate deliberately for light or dark areas and all those in between in such a way that you have complete control of the exposure outcome. Using this system you can be sure of achieving bright, deep colors, white snow, and black shadows.

To understand how it works, first divide a scale of values from black to white into five steps (see the accompanying table). This is a zone-value scale. Zone 1 represents the blackness of deep shadows and black objects, zone 5 represents white and very light highlights (not glaring white). The key to understanding this system is to realize that zone 3 represents middle gray. In other words, zone 3 is the zone your averaging reflectance exposure meter is programed to read. It is equivalent to the average of all the dark and all the light values in a normal scene.

52

Large areas of light in backlit scenes can mislead your meter and cause serious underexposure. Take close-up readings of shaded areas (here, the logs) where you want detail to show. Tri-X film; 21 mm lens; Olympus OM-1 camera.

area you see in your viewfinder or (in the case of hand-held meters) from the area covered by the meter's angle of acceptance. Even the highly touted spot meters read reflected light in the same way—they are just more selective because their angle of acceptance is much narrower. Your meter is geared to average the whole range of values, from light to dark, into one value—that of middle gray. Most of the time this works, and you just line up the meter needle with the indicator and shoot, getting a good exposure every time! (Well, almost every time.)

But what happens when your main subject is partly in bright sunlight and mostly in dark shadows, as was the case with the football players? The larger area of dark shadows will influence the meter's average, indicating that more light is needed on the *overall* subject. As a result, the

ZONE VALUE SCALE

more exposure (open up)	#5	- White with visible texture and detail
	#4	- Yellow - Red, light gray sidewalks
Middle Gray	#3	- Green, blue, grass, and medium-blue sky
(close down)	#2	- Deep blue, dark stone - Shadow areas
less exposure	#1	- Black with visible texture and detail

NOTE: Each zone represents one stop more exposure or one stop less exposure than the zone next to it, i.e., red is one stop more exposure than green.

Looking at the zone-value scale, you can determine which color brightness matches which zone. Then you can adjust the camera's exposure to that brightness. For example, the yellow uniforms would probably fall between zone 4 and zone 5. This is one and one-half zones away from middle gray (zone 3). Each zone represents one f-stop of exposure. Therefore all you have to do is open up the lens or adjust the shutter speed to increase the exposure by one and a half stops over your meter's reading. You are now ready to shoot for perfect exposure.

The same lighting situation can be approached from the opposite direction: Read the shadow area (it will probably fall between zones 1 and 2), then decrease exposure from that shown by the meter by closing down one and a half f-stops. Interestingly enough, either adjustment should result in about the same exposure setting.

All you are doing with this system is using any value, from black to white, as a reference point to determine the exposure. You are not stuck with middle gray,

and you have a system that will give you the correct exposure information for the results you want in the final photograph.

But still there may be times when you want the middle-gray exposure reading; then you can use a substitute object that has a middle-gray value. Take a reading, then shoot, using this reading, without adjustment. A green lawn is usually close to middle gray in value, and readily available. You can use the darkest part of a clear blue Northern sky in the same manner.

If you have access to something of black value and something of white value in the same lighting as the subject you plan to shoot, you can take readings from each of these objects and use a setting halfway between the two. This will also tell you how wide the contrast is within the scene. This can be an advantage if you do not want to lose either one or both ends of the exposure scale.

Usually it is best to take a reading from the main subject, adjust to expose for it, and let the rest of the values fall where they may. This will give you the best saturation (richness of color) in the subject.

HIGHLIGHT SYSTEM OF EXPOSURE

There is another system for obtaining super-accurate exposure that is simple to use and suitable for low-light photography. It has been called the *highlight system of exposure*. You need a hand-held incident-light meter for this system.

Here is how it works: Point the light-gathering dome of the exposure meter directly at the light source so that you get the highest possible reading. Then use that reading for your exposure. That's all there is to it! You may have to make some minor calibration adjustments (change of ASA settings) to get the results you want. One roll of film on

which you have shot various subjects under various lighting conditions should provide all the information you need to get near-perfect exposures every time. Be sure to include all lighting conditions you expect to work with—especially those where available light is low. You will notice some differences in emphasis under different kinds of light. You will probably have to increase your exposure slightly to get proper exposure in low-light situations, including shade and overcast light outdoors. And you will probably have to decrease your exposure somewhat for good color saturation in bright sunlight.

With this system you are setting the best exposure for the object that receives the most light.

This system is geared mainly to allow for the greatest amount of saturation possible in color slides. It can easily be adjusted to fit black-and-white and color negative films, however, by putting the emphasis on shadow or average-light readings. By pointing the light-gathering dome toward the light falling onto a shadow area, you would achieve maximum shadow detail in the negative film.

This approach is nothing new. It is consistent with the old timer's adage: "Expose for the highlights with color; expose for the shadow areas with black-and-white."

Along with these system adjustments and calculations, many professionals make it a habit to underexpose about half a stop below their meter's indication. I sometimes use an exposure as much as a stop and a half less than the meter reading to get the deep saturation and contrast I prefer with some subjects. Of course, if you calibrate your meter to take such preference into consideration, you will not need to do this. But I prefer to use a range up and down from the known neutral calculation.

No two photographers see or judge alike, and no two exposure meters read exactly alike; so you must make some tests to see where you and your equipment stand. Experiment to find which system works best for you and for

your equipment, and to determine how to calibrate your meter, and how much underexposure or overexposure will give the results you like. These kinds of tests are invaluable to give you confidence and control. Keep good notes of your tests, and refer to them often until all the techniques become second nature. This takes time and patience, but in the long run it will help you to be a capable and creative photographer. And you will be able to get those great shots, just the way you envisoned them, almost every time.

BRACKETING

After such a lengthy discussion on precise exposure, I am going to advise you to bracket the indicated exposure. That seems almost contradictory, but it really isn't. Let me share a personal experience to show what I mean.

I was shooting a night scene of Jerusalem, with my camera braced on a stone wall overlooking a large Jewish cemetery. I had taken a reading of the darkened sky with a supersensitive exposure meter and calculated a zone 1 exposure. This meant that I should close down two f-stops from the meter reading. I did this, and because I was in a hurry to meet some friends I rushed off without bracketing the exposure reading.

My calculated exposure with the zone reckoning came out just as it should have, but it did not match the previsualization that I had had in mind. Somehow my mind's eye had seen the scene as much more luminous. If I had bracketed the exposure, providing a margin of several f-stops either way, I would have gotten the picture I saw in my mind.

Often we see things through emotional eyes. Can you remember how people and places of your childhood looked after you had grown? I had a cousin that I always

thought of as being tall and large in stature. It came as a great shock to me to see, years later, that he was actually a small man.

This should almost be a rule: Scenes appear brighter and more luminous than they really are. Maybe this is due to eternal optimism. Whatever the reason, if this phenomenon occurs with you, take it into consideration when you calculate exposure. You should shoot at least one or two extra bracketing exposures to give yourself a choice.

Sometimes "wrong" exposure gives right results. Here, deliberate overexposure washed detail from the wall so that the racing carts and stable doors are emphasized. Exposure reading was made of shadow area and increased one stop. Shot at the Hippodrome in Cagnes-sur-Mer, France, on Tri-X film; 50 mm lens; Olympus OM-2.

An automatic-exposure camera is the easiest to use for bracketing; all you have to do is turn the bias knob a couple of half-stop clicks in both directions.

If the depth of field is not critical, it is best to change the aperture settings rather than the shutter speed when bracketing. This permits half-stop brackets and will preserve the same color balance for all variations—because the reciprocity failure will be the same for all frames. You should expose at least one stop over and one stop under, half a stop each time, exposing a total of five frames. On a really critical shot, I expose as many as nine frames.

If the shutter speeds are alterable, and the aperture setting is critical, vary the shutter speed in one-stop increments. Now you can see another advantage of the automatic-exposure camera with half-stop bias-control clicks and a stepless shutter-speed control.

7

The Many Modes of Low Light

It has been said that a photographer uses light the way a painter uses a brush. This seems particularly appropriate when not much light is available: Like the brushwork of a Monet painting, soft and subdued low-light conditions can form images of subtle hues and shapes. While most low light is of a diffused nature, it can vary from flat, soft illumination to harsh directional light such as that produced by stage lights. Its color effect can range from the "colorless" blue of moonlight to the brilliant oranges of sunset.

It would not be feasible, within the scope of this book, to give detailed directions for all possible low-light conditions. Such conditions are almost as numerous as the photographers who shoot under them. However, the most frequently encountered forms of low light will be examined.

For the sake of discussion, this section will first describe individual available-light conditions and then explain the advantages and problems of each. There will, of course, be some overlap into material presented in other chapters.

Under soft light of overcast sky, exposure was decided from reflected-light reading of window plus one stop. Plus-X film; 85 mm lens; Nikon F camera.

Window light models faces gently. Tri-X; 35 mm lens; Nikon F.

SHADE

There are two main types of shade. The most useful is open shade, which results when a wall, a building, or some other more or less vertical object blocks the direct sun but there is clear sky overhead. Open shade resembles the soft, nondirectional light under an overcast sky. Open shade is very good for portraits and for candid photography.

Closed shade, or deep shade, is the heavy shadow underneath an object such as a porch or a dense tree. It is nondirectional, soft, and low in contrast, or "flat."

Many photographers have become quite skilled in the use of controlled shade for portraiture. This technique uses light-blocking screens (called "gobos") to remove or direct the light as needed. This lighting is appropriately called *subtractive lighting* and is probably the most flattering and sensitive portrait lighting being used today.

Any kind of shade produces a bluish cast and should be corrected with a warming filter. An 81A filter works well, but you may want to use an 81 or an 81B for less or more of the warming effect. Also, a polarizing filter seems to eliminate some of the bluish cast caused by shade and by overcast light. The polarizing filter, when used in

Highlight-reading technique was used to determine exposure as the author's daughter, Mary, stood in shade cast by the tree.

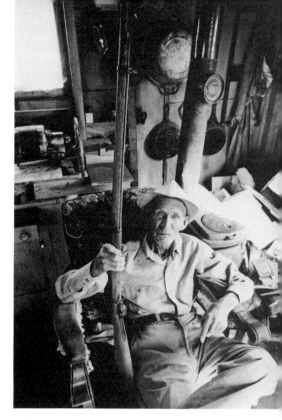

Vertical use of 35 mm wide-angle lens fits Uncle Ben and his son's workshop into the frame. Nikon F's behind-the-lens meter was used to measure light from several windows. Tri-X film.

conjunction with an 81A filter, gives especially warm, rich colors. Its only drawback is the one-and-a-half-stop to two-stop increase in exposure needed. Some experts say the skylight or ultraviolet (UV) filter is sufficient for compensating for the excess blue of shade and overcast days, but it never seems quite enough for my taste.

WINDOW LIGHT

Window light, without the direct rays of sunlight, is often used for portraits because of its soft, but gently directional, quality. It has a beautiful modeling effect on form and face but, because of its directional quality, a reflector is sometimes needed to fill in the shaded side of the subject.

The light in this shady portrait is really too flat, but it suits the intimate mood and the man's penetrating expression. Plus-X film; 85 mm lens on Nikon F camera.

A marvelous window-light portrait arrangement can be set up in a room that has windows at right angles fairly close together in the corner of the room. This arrangement makes it possible to adjust the ratio of key light and fill light—that is, the main light and the secondary light—by moving the subject closer to one of the windows.

Window light can be warm or cool or in between, depending on time of day, weather, and position of the window. Usually, with color film it is best to use a warming filter (such as an 81A) with window lighting.

Filmy curtains can be hung in front of a window to soften the light if it is too harsh.

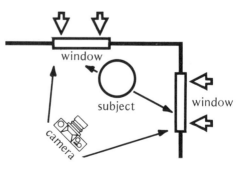

OVERCAST DAYS

My favorite low-light condition is the overcast day—especially just before or just after a storm. Blue skies and puffy white clouds do not have the same drama and color magic as a gray or stormy sky. There is something about an overcast day that makes everything seem more real in a photograph; the colors are muted and delicate, without the garish dishonesty of bright-sunlight photographs. There are touches of loneliness and of love in an overcast day.

The colors of overcast lighting can be quite strong in their own way, especially just following an afternoon storm, when the golden light of the sun barely filters through the hazy, rain-cleaned air. At such times, the colors are brilliant but not garish.

Overcast lighting is generally bluish and so must be filtered to give a normal-looking color balance. Again, as under similar conditions discussed earlier, an 81 filter (A, B, or C) will make the colors appear more natural by "warming" them—strengthening the reds and/or yellows. It sometimes helps to add a CC10Y (color-correction-10 yellow) gelatin filter, as well. You will have to experiment to see what combination of film and filters works best for

65

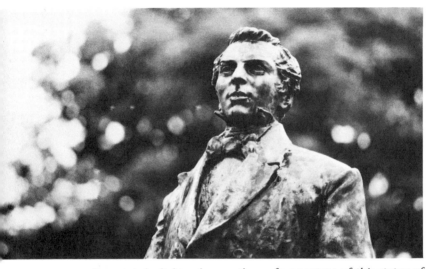

*Overcast daylight enhances the surface texture of this statue of
Joseph Smith, the Mormon leader, in Salt Lake City, Utah.
Exposure on Tri-X film determined by close-up averaging-meter
reading of the statue. Nikon F with 50 mm lens. Printed on
Grade 3 contrast paper.*

you in the situations you shoot most of the time. Different
latitudes and different areas of the country have differing
intensities and hues of color under overcast skies.

The softness of overcast lighting is usually quite
flattering to peoples' faces: It is relatively shadowless and
produces the soft, muted colors that bring out the best rep-
resentation of the face. Don't forget to use an 81A (or 81B)
filter to warm the color. (See the appropriate tables in
Chapter 8 for other filter corrections.)

This soft gradation and muted effect are also appar-
ent in black-and-white photographs. The prints can have a
richness and depth of tone that will surprise you. This is
especially true if you use paper of a higher contrast grade
than usual.

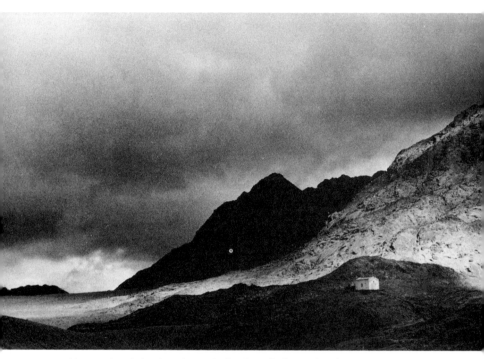

Heavy clouds broken by a shaft of sunlight evoke the strangeness and loneliness of the Sinai peninsula landscape. A 200 mm telephoto lens was used on Nikon F camera; Tri-X film.

FOG-RAIN-SNOW

Inclement weather can offer opportunities for unusual photographs. As you enter into the world of mist and semidarkness you will see graphic geometric shapes that appear isolated and unreal. Houses and trees become rectangular blocks and irregular spheres. And people become a part of the landscape, as though they were attached to it like trees and flowers.

67

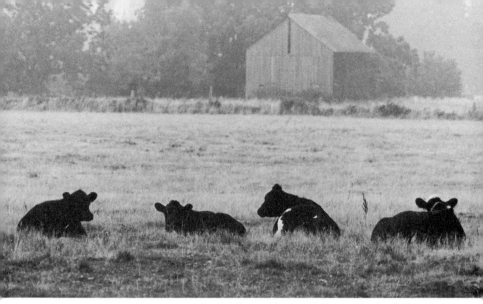

The muting quality of light fog in this rural Oregon scene helps isolate the black forms of the cows lying in the grass; telephoto lens (200 mm) adds to the effect. Determining exposure from the grass produced slight underexposure. Plus-X film; Nikon F camera.

The moods of bad weather change and flow. Within the space of minutes, even seconds, the mood of a scene can change from sombre to humorous. The ever-changing character of stormy weather is interesting in itself and an exciting challenge to the photographer.

Under stormy conditions the light is weak and very diffuse. Few if any, shadows are seen. The extremely soft lighting covers details like a visual blanket; only the strongest tones and shapes are recorded. Because the secondary details are blotted out, it is possible to place pointed emphasis on the subject—the background dissolves into gradual tones of gray or white. Color is minimal, and at times it disappears completely. Even bright-colored objects take on an air of softness.

Relationships can be bizarre in foul weather, with people and trees looking strangely alike and the earth blending into the objects standing and growing on it.

Parks and such usually crowded places suddenly become empty and still. In this quiet atmosphere the pho-

tographer can present feelings and moods that would be difficult to portray on ordinary days.

Rain brings with it muted tones and colors, reflections that dance on wet pavements with colored designs and accents. If you want abstract or distorted, dreamlike images, just shoot the reflection itself. Be sure to focus on the reflected image, not on the water's surface.

Black-and-white photographs of rainy days can be very effective, too. Look for blending of shapes and for interesting patterns. The muted tones of a rainy scene can be accented by dark tree trunks, or other dark objects, in the foreground. Many objects appear different in tone and texture when photographed while they are wet.

Fog can mute a scene even more than rain does, sometimes eliminating everything but the largest or closest objects. Foggy conditions lend an air of mystery to commonplace scenes and things.

Heavy fog blends trees, parking meters, and ground. Tri-X film, exposed according to the Nikon F's built-in meter; 50 mm lens.

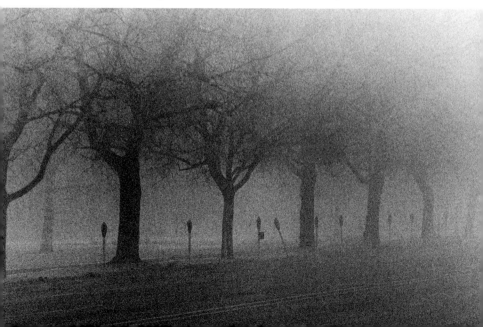

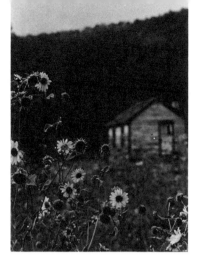

To eliminate rain streaks in this Arizona mountain scene, shutter speed of 1/60 was chosen. This is slow for a telephoto; so the Nikon F and the 200 mm lens were braced on a fence post. Tri-X film.

Night fog and backlights can create drama. Exposure was determined by averaging from readings by a very sensitive incident-light meter.

One advantage fog has over rain and snow is that it is relatively less wet and cold. It may be a bit damp, but it is not running-water-wet like rain. Usually protecting your camera with a coat is the only precaution you will need to take. The latter part of this chapter gives some hints for wet-weather camera protection and other advice for photographing in bad weather.

Photography in the snow can be a lot of fun. People are usually quite active, and there is an excitement that goes with the season. Even in city parks there are winter sports, children playing in the snow, and snow-becrystaled trees. In the countryside you see a calm, unfolding whiteness stretching out, as if into infinity. You will be captivated by restful landscapes and simplicity of design.

The author, too, hiked to school in the snow in southern Utah. A long shot from a window at fast shutter speed: 1/125 sec. on Tri-X film with a 200 mm lens. Exposure was two stops over the Nikkormat's behind-the-lens meter reading, as directed by the Zone exposure system.

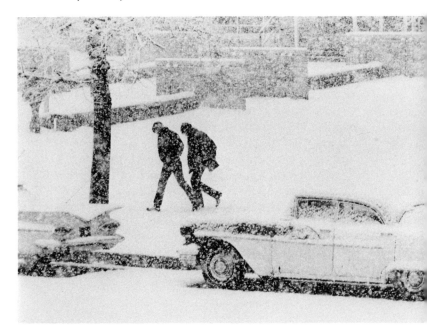

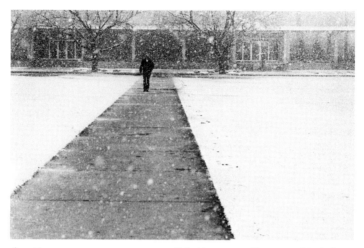

Another snowy campus scene: this time, a walkway at Utah State University. Exposure was determined by reflected-light reading of the snow plus two stops, as in the previous illustration.

There is usually a tendency to underexpose in the snow because photographers tend to forget that exposure meters do not allow for the stark whiteness of the background. Even if you use the zone system explained in Chapter 6, you should be aware that the slightest overexposure will wash out detail in the snow and the smallest amount of underexposure will muddy the delicate shades of white. Sometimes I prefer to overexpose the black and white negative, so that the white areas lend pure and abstract qualities to the scene; but in color that kind of effect would not be as pleasing or possible.

The greatest problem in photographing in inclement weather is one of exposure. There is a tendency to underexpose, and so you should bracket more on the overexposure side. That is, shoot one frame according to your meter reading, one at half a stop less, then expose several frames at half-stop increments more exposure. Again, you

will have to experiment to find the range that best expresses your feelings about bad weather conditions. Sometimes a darker-than-normal photograph will express your mood; at other times, the luminosity of a slightly overexposed photograph will be characteristic of your feelings. There just aren't any hard-and-fast rules.

EQUIPMENT PROTECTION IN FOUL WEATHER

A raincoat draped over your camera is the simplest form of protection. Be sure to put a skylight (haze or UV) filter on your lens, to keep the water off its surface as well as to help control excess blue when shooting in color. Carry a fairly large kitchen towel with you to wipe the large drops of water off the camera body; lens tissue can be used to wipe the filter.

An umbrella keeps things a lot dryer, but you will need someone to hold it so you will be able to make camera adjustments and shoot. If you cannot persuade a friend to help, then you can put together a "C" clamp arrangement to do the job. Take two "C" clamps and a tripod ball-and-socket assembly. Now drill and tap the outer edge of the "C" clamps (see illustration) with a ¼ × 20 tap. Screw the threaded male portion of the ball-and-socket assembly

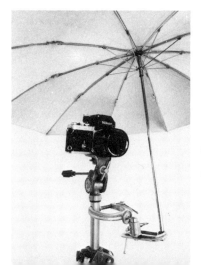

This is how the "C"-clamp bracket mentioned in the text holds an umbrella over the camera for stormy weather photography. Use the ball-and-socket joint to adjust the umbrella to protect your valuable camera and lens:

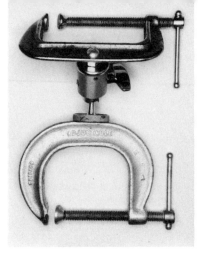

A closer view of the "C"-clamp arrangement shows why it can pivot to virtually any position.

to the tapped "C"-clamp hole. Take a ¼ × 20 stove bolt, cut off about an inch of the threaded portion, and screw it into the threaded female part of the ball-and-socket unit. Screw the other end into the remaining "C" clamp. And there it is—a clamping device that will hold the umbrella upright while attached to a tripod leg, fence post, or anything else that is handy. It helps to file a groove in the fixed jaw of the "C" clamp, so that the umbrella stem will not twist out of the clamp.

If the "C"-clamp arrangement is beyond your mechanical skills, then let me offer you another easy solution. All this one takes is a plastic bag, a rubber band, and a filter to cover your lens.

Place the plastic bag over your camera, with the open part of the bag below the bottom of the camera. Poke a hole in the bag, enlarging it until it fits tightly around the front end of the lens. Wrap the rubber band very tightly around the plastic on the front end of the lens (with the filter attached, of course). Now you can shoot with the camera either on a tripod or held in the hand. Just mold the plastic around the knobs when it is necessary to make adjustments. There are several underwater housing units commercially available for 35 mm cameras. They work quite well, but I find them a little stiff and awkward to use. Besides, the sandwich bag is a lot cheaper.

74

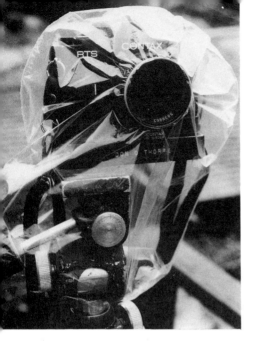

Above: *A plastic bag with a hole
cut in it can protect your camera
on a tripod or in the hand.
Be sure to use a filter, too.*
Right: *A rubber band holds the
bag securely in place. The
filter keeps rain off your
valuable lens.*

Don't forget to keep yourself dry and warm. That
may seem like useless advice, but your feelings of comfort
and well-being are almost as important as the condition of
your camera. You will not get good photographs if you feel
uncomfortable and can't wait to get inside where it is
warm and dry.

Of course, the ultimate in keeping dry and comfort-
able is to shoot from a house or car. If you do this, make
sure you shoot from an open door or window. This may
limit your mobility somewhat, but you'd be amazed at the
great shots you can get, especially from a car.

SUNSETS, TWILIGHT, AND DUSK

Sunrises and sunsets are the most photographed, and some of the most dramatic, low-light subjects. Getting a sunset picture that is not like all the rest, however, is a challenge.

A silhouetted object in the foreground does a great deal to add drama and interest to a sunset picture, whether the photograph is black and white or color. (By the way, black-and-white sunset photographs can be very attractive. It is even possible to tone a black-and-white print to make it look like color.)

The best way to get an exposure reading is to point your meter (or camera with built-in meter) toward the sky, on the same level as the sun but 45 degrees to the left or right of it. Shoot with that reading, and bracket. Do not look through your viewfinder directly at the sun, except for a very brief moment during the actual exposure. Prolonged visual contact with the sun through the viewfinder can damage your eye permanently.

If the sun has set, point your meter at the brightest part of the sky and shoot with the indicated reading.

A little overexposure will produce luminous, bright tones, while a little underexposure will give more drama and more deeply saturated colors. It is always a good practice to bracket.

Twilight and dusk offer a subtle combination of night and day. You get some feeling of night, with a little of the visibility of day. Buildings are generally visible in some detail and show the lights inside them. The sky is still bright enough to be colorful and light. It is truly one of the magic moments.

Facing page: *Exposure of this stark sunset over a pond in Far West, Missouri, was established by reading the sky directly overhead with the meter in the Nikon F2. The 20 mm lens was hand-held at 1/250 sec. Black-and-white Tri-X film was used, not color film.*

Dusk and twilight are bright enough so that you can hand-hold for some shots; but it is best to steady the camera and bracket widely. Your exposure reading should be taken from the overall scene without including too much

The sun had just set over Genoa, Italy, and there was barely enough light to hand-hold at 1/15 sec. Photographed on Tri-X film with a 21 mm wide-angle lens on an Olympus OM-2 body. The shot was bracketed to be sure of having a negative that did not overexpose the street and house lights.

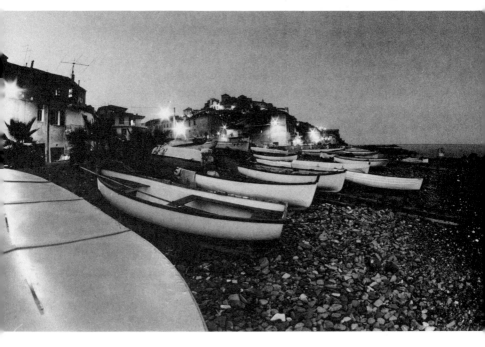

of the bright sky. Or you can try to use the zone system. But this kind of lighting is very deceptive—things are not as they appear. So, bracket two or three stops and keep notes, so that you will know later what worked the best for you.

NIGHT PHOTOGRAPHY

Although difficult in some ways, night photography is the easiest form of available-light photography and has much to offer. Night is the extreme of the low-light scale, but it still provides many opportunities for hand-held photography. This section on night photography is concerned with outdoor situations. Indoor lighting will be covered in separate sections.

Night photographs exhibit a brilliance and contrast that you cannot get under any other light conditions. The vivid colors of electrical signs are contrasted against the black of night, and the snaking streaks of car lights jumble together within a glowing city.

A wide range of effects awaits you in the glow of the city at night. You can shoot anything from sharp, detailed floodlit buildings to fluid road-scapes with curving lines of lights; even candid people-pictures are possible under the spilling light of city street lamps.

It is possible to shoot hand-held shots, but take along a tripod or some other steadying device for long shots of the city and its colored lights. You will also need a lens shade to minimize flare when shooting into the lights.

With regard to film, stick with Kodachrome 64. It is the nighttime champ. Daylight film works best for outdoor night photography; the added warmth looks more real than type B film, even though the latter is correctly balanced for incandescent (tungsten) lights of signs, house lights, and so on.

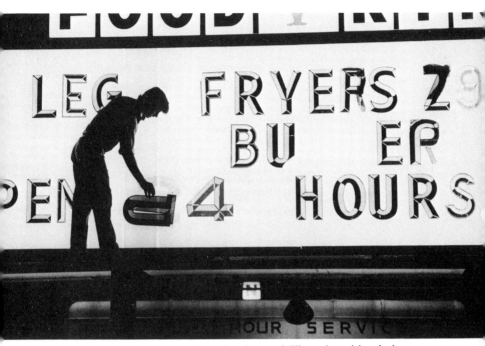

The graphic impact of this food-store billboard could only have been captured at night. Exposure was determined from the chart on night exposures, then bracketed.

Since it is nearly impossible to get exposure readings of large areas of night light, you might consider the following combinations, which several good photographers have found to work very well. You will find more complete information in the accompanying night-exposure table.

Night exposures of large areas usually range from 15 to 60 seconds at *f*/5.6 with Kodachrome 64 film. Tri-X or Ektachrome 400 would give you 2 sec. to 8 sec. shutter speeds at the same *f*-stop; however, if you were to open up to *f*/1.4 you would get ⅛ sec. to ½ sec. shutter speeds—al-

NIGHT AND EXISTING-LIGHT EXPOSURE GUIDE

Subject	Exposures for Daylight Color or Black-and-White Film		
	ASA 64	ASA 200	ASA 400
Neon lights (close)	f/2, 1/30 sec.	f/2.8, 1/60 sec.	f/4, 1/60 sec.
Night street scenes	f/1.4, 1/30 sec.	f/2, 1/60 sec.	f/2.8, 1/60 sec.
Floodlit buildings	f/8, 16 seconds	f/8, 4 seconds	f/8, 2 seconds
Moonlit scenes	f/8, 2½ min.	f/8, 40 seconds	f/8, 20 seconds
Bright city lights	f/5.6, 15 seconds	f/5.6, 4 seconds	f/5.6, 2 seconds
Fireworks and lightning	f/5.6, open	f/11, open	f/16, open
Skylines (10 min. after sundown)	f/2.8, 1/30 sec.	f/4, 1/60 sec.	f/5.6, 1/60 sec.
Night football, etc.	f/1.4, 1/60 sec.	f/2.8, 1/60 sec.	f/2.8, 1/125 sec.
Home interiors	f/1.4, 1/15 sec.	f/1.4, 1/30 sec.	f/2, 1/30 sec.
Fluorescent scenes (bright)	f/1.4, 1/15 sec. with CC40M	f/2, 1/30 sec. with CC40M	f/2, 1/60 sec. with CC40M

most in the realm of hand-held shooting, especially if you use a chest pod as mentioned in Chapter 4. (See the accompanying table for other estimated low-light exposures.)

As you near the center of the city, the light intensity rises and becomes more workable. You can now shoot bright neon lights, hand-holding the camera at 1/60 sec. with a lens opening of f/4 with ASA 400 film. Average street scenes usually can be photographed at 1/60 sec. at f/ 2.8, but at this point you can probably use your meter to get accurate exposure settings.

Just a word about composition in night photographs. When lights and buildings fill the picture area, all you need to remember is to stand where patterns and shapes will be arranged in an interesting manner. When the picture area includes a large amount of dark sky, however, try to place a silhouetted object, such as a tree, in the blank sky area. This will not only fill some rather uninteresting area but also provide a foreground object to create a sense of depth.

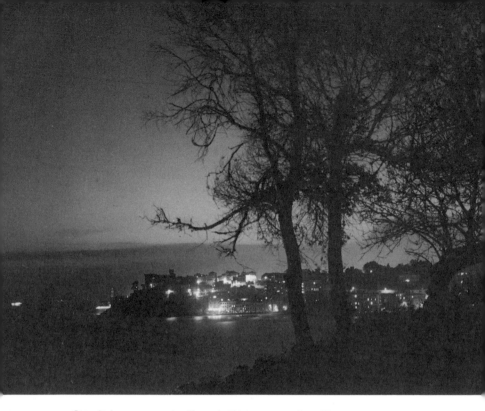

City lights accent the French Riviera at night. Photograph taken with a 2¼-square-format Hasselblad (with its 80 mm normal lens); guessed-at time exposure bracketed as explained in the text.

FIREWORKS AND LIGHTNING

This is the simplest of all night photography. All you have to do is turn the shutter control to "bulb" or "T", open up the shutter, and wait for a couple of bursts or flashes before closing it again. With ASA 400 film an approximate *f*-stop would be *f*/11; with Kodachrome 64, try *f*/4.

ARTIFICIAL LIGHTING

When it comes to indoor lighting with artificial light sources, the color-balance problems are multiplied (see Chapter 8) and become the biggest difficulty. Incandescent lights, whether household bulbs or photoflood lamps, vary

a great deal in color temperature. There are also fluorescent lights, with their awful greenish glow, and (heaven forbid) the nearly uncorrectable mercury-vapor lights found in many sports arenas.

INCANDESCENT LIGHTING

Most of the time you can get by under incandescent lighting with type B film (or daylight film with an 80A filter). You can even shoot type B film outdoors with an 85B filter over your lens. (In fact, many photographers believe that type B Ektachrome 50 or 160, used with the 85B filter, gives the most accurate color rendition for outdoor photography.)

FLUORESCENT LIGHTING

A general suggestion for fluorescent lighting which works for me is the following: A CC40M (color-correction–40 magenta) gelatin filter corrects the color cast of most fluorescent lights. But you have to contend with a 76 mm-square (3-inch-square) filter holder and an effective loss of film speed of about two ƒ-stops. Even when reading the light through the filter with my BTL (behind-the-lens in-camera) exposure meter, I still have to open up about ½ to 1 ƒ-stop from the reading obtained through the filter. By the way, the gelatin filter is very delicate; so take special care of it.

Most tables on color balance say that a CC30M filter gives the proper correction for average fluorescent lighting, but I have found I still get a touch of green with the CC30M. Sometimes the CC40M is just a little too warm, but

I believe it is better to be too warm than too bluish or greenish. The eye can more easily accept things that are a little too warm.

You may be caught in a situation where there is a brightly lit room that has both fluorescent lights and also a window letting in some daylight. If you cannot block out the window, what do you do? The CC30M, or even a CC20M filter in this case, can roughly balance the daylight and the fluorescent lights. The flesh tones will not take on an unnatural pink, and the windows will not look magenta.

Since fluorescent lights come in an assorted mixture of color temperatures—warm white, cool white, and daylight, to name a few—it is not possible to match, exactly, the color balance for all with a single filter. With an expensive color-temperature meter and a box of gelatin filters you might be able to come close—but even then you would probably still have a little green.

A friend of mine once found the ideal system for shooting with fluorescent lights—but unfortunately processing chemicals and films have changed since then, making the solution no longer viable. I mention it here in the hope that some film manufacturer will seize the opportunity to respond to a need. My friend had found, after much trial-and-error experimentation, that Fuji 100 film (the old E4 kind), when shot without filtration and processed in E3 chemistry, perfectly balanced the light of most fluorescent tubes. My friend and I both used this arrangement successfully for several years until the E6 films and processing crowded out the other processes. Why can't some film manufacturer produce a film that would have those same qualities when processed in E6 chemistry? It seems to me that fluorescent lighting is becoming the norm in most buildings and offices; in many ways a fluorescent-balanced film would be much more useful than the readily available type B films. Much of low-level available-light

84

photography now being done is shot under fluorescent lighting.

MERCURY-VAPOR LIGHTING

These lights are difficult to color-correct. It is said that a CC50R (color-correction–50 red) or a CC80R gelatin filter does a pretty good job. But be sure you use a slow shutter speed because this light pulses, with drastic results at shutter speeds of 1/125 sec. and faster. Fluorescent lights also fluctuate a little during each AC cycle (alternating current), but the effect is minimal if you shoot at a speed slower than 1/125 sec. At any rate, the effect is not as pronounced as with mercury-vapor lamps.

STAGE LIGHTING

This type of lighting is undoubtedly the most difficult of all artificial light to monitor for exposure. It also

Spotlight captures Spence Kinard, announcer for the weekly broadcast by the Mormon Tabernacle Choir of Salt Lake City, Utah. Olympus OM-1 camera with 75–150 zoom lens; Tri-X film. Exposure was determined by a close-up incident-light reading at the podium before the broadcast, "Music and the Spoken Word," began.

creates problems with extreme contrast and color balance. Often there is a spotlighted subject and an unlighted or dark background. Even with a meter that reads a one-degree spot, it is almost impossible to get an accurate light reading unless you are in the front row, and even then it is chancy. The greatest danger is overexposure of the subject because of the predominance of dark areas behind it (review Chapter 6). The best solution is to get close-up readings of sample lighting situations before the performance begins.

If you have to shoot without prior tests or readings, let me offer you a system that a photographer friend of mine has devised. I have used it and found it to work adequately under most stage conditions. He recommends using Ektachrome 400 daylight film shot constantly at 1/250 sec. at $f/4$. His favorite optic for stage shows is an 85 mm $f/2$ lens.

Stage shows use a variety of colored gels on floodlights and spotlights. They also use carbon-arc lights, which have a color balance close to that of daylight. All these types of stage lighting reproduce best on daylight film. The high speed of Ektachrome 400 is an added bonus, especially since the film can be used without light-diminishing filters.

8

Unique Problems of Low Light

Low light brings with it some unique problems that go beyond exposure, an unsteady camera, and difficulty in seeing to focus. Besides constant variation in color balance and lighting contrast, there is a host of other factors that do not usually confront the daylight photographer. Sometimes these factors can become assets and sometimes they cause situations that are impossible to work with. But the challenge is there, and that is what makes low-level available-light photography so exciting.

FLAT LIGHTING

Too little contrast, caused by nearly shadowless lighting, makes three-dimensional objects appear less contoured, and so this kind of light is called "flat." While soft lighting gives gentle, gradual definition to objects, flat lighting is generally encountered on dull, overcast days and in deep shade.

There are several techniques to add modeling and contrast to the subject you are photographing under flat light. Using a contrasty film like Panatomic-X or Plus-X helps. Another solution, which boosts contrast and effective film speed, is to underexpose (by doubling your ASA

A merging of tones generally does not help a photograph, but here it seems to emphasize unity between these two Orthodox Jewish boys in Israel. Slight underexposure added to this effect. Agfapan 400 film; 85 mm lens on Nikon F camera.

rating, for instance) and overdevelop. Or you can use a higher numbered (harder, more contrasty) printing paper in the darkroom.

Some color slide films have more contrast than others, which is one reason I use a lot of Kodachrome 64 in low-light conditions. You can "push" some color films to gain contrast; for this, I generally use the fast Ektachromes —ASA 200 and 400—if slight graininess is no problem.

CONTRASTY LIGHTING

On the other end of the scale are the extremes of contrast found in stage lighting and bright sunlight. Here the problem is most often solved by exposing precisely for the subject while letting the dark areas go underexposed.

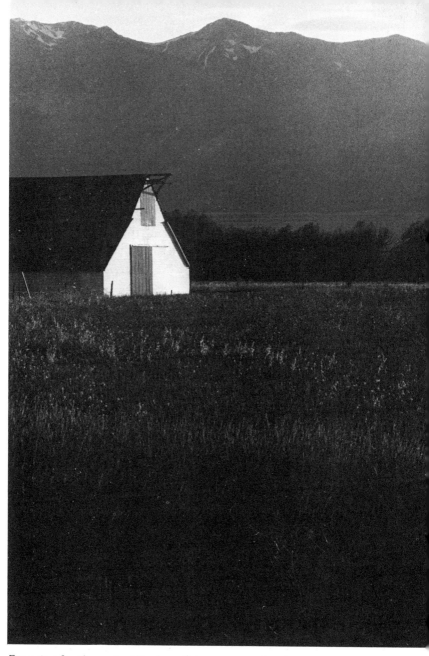

Exposing for the end of the barn (plus one stop for detail in shadows) stresses scenic contrast. Tri-X film; 200 mm lens; Nikon F camera.

89

In situations where you would like to see detail and images in the surrounding area, however, something must be done to lower the contrast of either the scene or the film. If possible, move the subject away from the source of strong light so as to reduce the subject-to-environment contrast range. While this can be done in a room or office location, it is almost impossible to do on the stage or in other spotlighted areas. The alternative is to add some light in the shadow areas with reflectors or with supplemental artificial light—that is, "fill in" detail in the deep shade.

When it is impossible to either move the subject or change the lighting ratio with fill lights, you can resort to exposure and developer manipulation. In this case, you do the opposite of what you would under flat-lighting conditions—you *overexpose* the film and *underdevelop* it. This cuts down the contrast ratio. Or, for black-and-white photography, use a compensating developer, such as D-23, that will continue to develop the less-dense areas of the negative while leaving the highlight areas alone. With color transparency film, overexpose by one *f*-stop and underdevelop—just ask the lab to *down-rate*. A developing formula for black-and-white contrast reduction can be found in Chapter 14.

TONE MERGERS

When two overlapping objects have approximately the same color or value, a *tone merger* usually results. This means that the two objects may blend, appearing as one object—like the dark coat "lost" in the dark doorway. This becomes more of a problem with black-and-white than with color because colors of the same tonal value may be of different hues and thus be separated from each other by contrast of the color.

90

Here, tone merger takes the photograph beyond a literal statement of fact. Building and trees become one, hinting at the sometime relationship between mankind and nature. Slight underexposure of Tri-X film; 200 mm lens on Nikon F camera.

Separating adjacent or overlapping tones can make the difference between a good low-light picture and a bad one. Separating the subject from the background is crucial. In fast-moving and spontaneous situations, try to position yourself so that a background of contrasting hue or tonal value is behind the subject, or wait for the subject to move into that kind of position. Remember to shoot immediately, then continue shooting until the right positioning occurs—you might miss the picture altogether if you waited for perfect conditions. Afterward it may be possible to lighten or darken the subject or background in the darkroom by dodging or burning-in the print.

It is important to wait for just the right moment to achieve separation and position. Tri-X film; 135 mm lens; Nikon F camera.

COLOR BALANCE

While photographing for a client some artifacts from the Brigham Young home in Salt Lake City, I used a regular household 100-watt incandescent (tungsten) light bulb behind a diffusion screen to simulate natural light (this technique is described in Chapter 9). I draped Brigham Young's Nauvoo Legion belt and sword over a black horsehair chair and directed the soft, diffused light onto the gold-colored metal on the belt and sword. The bulb and diffusion screen were very close to the objects, and there was a window about 4.6 m (15 feet) away. It was a dark, overcast day, and not much light was coming through the window, so I figured that the film's color balance would not be affected—I was using indoor (tungsten) film, Ektachrome 160, type B. However, after the slides were processed I noticed a definite blue cast on the rim of the black chair. Even that small, seemingly insignificant amount of daylight was enough to affect the color in part of the photograph. Luckily for me, this time the color cast worked to create an interesting mood and color harmony

92

in the picture. This is the kind of problem that can be a nuisance when shooting under mixed light sources. (See the accompanying color-correction tables.)

Although it is not apparent, each light source has its own color properties—blue or red or green. We do not notice these differences under normal conditions because the brain adjusts our color perception to balance out the light source. But if the different types of light could be compared it would be evident that they differ drastically in color cast. The light from a clear day would appear bluish, the light from an average household bulb would appear yellowish, and the light from a fluorescent bulb would appear greenish.

You can begin to see the differences by performing an experiment. Lay an open book, with only white printed pages showing, on a table next to a window that lets in diffused daylight. Now, put an ordinary (incandescent, or tungsten) table lamp next to the side of the book farthest away from the window. Hold a large, opaque white card

COLOR-CORRECTION TABLE FOR DAYLIGHT FILM

Type of Lighting	Filter to Achieve Normal Rendition
Open shade	81A (or 81B, 81C)
Overcast day, closed shade	81B, (or 81C, 81D)
Very light overcast	Skylight filter
Late afternoon	82 (or 82A, 82C)
Incandescent bulbs	80A
Floodlights	80A
Photoflood lights	80B
Fluorescent lights	CC40M (or CC30M, CC10M + CC20B)
Mercury-vapor lights	CC80R (or CC50R)
Light coming through plastic windows	CC30R

NOTE: Remember that this chart is approximate—people see colors differently, and some prefer colors warmer or cooler than others do. Also, film emulsions vary from batch to batch and thus vary color balance. You can only get sure results by experimenting and shooting your own tests.

upright in the center of the open book. Visually balance the intensity of light on both sides of the card—on one side, the windowlight; the other side, the lamplight. You will notice, at this point, that the daylight side appears faintly blue and the lamp side appears slightly yellow. This little experiment demonstrates quite clearly the differences in the color properties of different light sources.

Although your eyes do not normally see the differences in color among various light sources, the film in your camera is very much affected by these differences. Daylight film turns a strong yellowish-orange when exposed under incandescent (tungsten) light. Indoor film (type B) turns a definite blue when exposed to daylight. The worst offender of all, fluorescent lighting, gives all color films a greenish cast.

This is only part of the predicament, for different times of day show variations of color cast. The closer you get to sundown, the more reddish the light becomes. Overcast or shadows on bright days bring a bluish cast to the scene.

WARMING AND COOLING FILTERS

Color of Filter	Filter	
	85B	**Warmer**
Yellowish pink	85	↑
	85C	
	81EF	
	81D	
	81C	
Pale yellow	81B	
	81A	
	81	
	82	
	82A	
Pale blue	82B	
	82C	
	80C	↓
Blue	80B	**Cooler**

94

Artificial light sources also vary greatly. Color-temperature charts (in Kelvin degrees) will give you some idea of the approximate amount of variation. But even if these charts were exact you would still need a color-temperature meter to measure and then modify the light to meet your requirements. Color-temperature meters are very expensive. The accompanying table gives guidelines that will help you match film and lighting conditions to a largely acceptable degree.

COLOR-TEMPERATURE COMPARISON TABLE

K Degrees	Light Source	
10,000–27,000	Light from clear blue sky	**Bluish (cooler)**
7500–8400	Light from hazy sky	
7000	Electronic flash	
6800–7100	Overcast daylight	
6000	Blue flash bulbs	
5400–6500	Direct sunlight between 10 AM and 3 PM	
4800	Blue photoflood lamps	
4500	Dusk and twilight	
3400	Photoflood bulbs	
2500–4500	Incandescent household bulbs	
1500–4500	Sunrise and sunset	
1500	Candle flame	**Reddish (warmer)**

NOTE: This chart gives only approximations; it is useful to the extent that it acts as an approximate guide to the films and filters than can be used—when used in conjunction with the color-correction table in this chapter.

It is not always necessary to match the color balance of the film with that of the light source. You may want to express the warm intimacy of a home by using daylight film under incandescent lights. Or you may want to increase the cold effect of a winter scene by using indoor film in the late afternoon or evening. Sometimes a mixture of light sources can create interesting contrasts.

On the other hand, you can correct the color balance of sunset lighting so it does not appear reddish but

rather looks like midday light. I often shoot in late afternoon because I *want* the reddish effect.

In the other direction, the problem becomes more serious. An overcast day, or open shade on a clear day, gives a bluish cast that is thought undesirable most of the time.

Remember that accurate color reproduction is not always the best solution; sometimes a mismatch of color balance creates a more truthful representation than the "real" colors would. It may be that your personal interpretation, based on your perception, is more expressive of the truth. Your feelings about people, events, and objects are most important to your photography. And if you are true to your own impressions, others will find your photographs believable.

RECIPROCITY FAILURE

The failure of a film to adhere to a linear scale of exposure and color response is called *reciprocity failure*. Each film responds in its own unique way to longer-than-normal exposure. (See the accompanying table of reciprocity-failure corrections for several popular films; for correction information for other films, write to the film manufacturer or consult reference booklets they publish.)

Most films need very little correction at exposures of less than one second; so your hand-held shooting in low light will not give you very many problems.

Some photographers, including myself, occasionally like to make use of reciprocity failure to achieve an offbeat color effect in a photograph. From the accompanying table, you should be able to tell which color a specific film will emphasize. The color shift brought about by reciprocity failure will be opposite the color needed to correct it for normal color balance.

RECIPROCITY-FAILURE CORRECTION TABLE

Film	1/10 Sec.		1 Second		10 Seconds		2 Minutes	
	CC Filter	Exposure Increase	CC Filter	Exposure Increase	CC Filter	Exposure Increase	CC Filter	Exposure Increase
Kodachrome 25	None	None	CC10M	1 stop	CC10M	1½ stops	CC10M	2½ stops
Kodachrome 64	None	None	CC10R	1 stop	NR	NR	NR	NR
Ektachrome 64	CC10C	½ stop	CC20C	1 stop	CC30C	2 stops	CC40C	3 stops
Ektachrome 64 Prof.	None	None	None	1 stop	None	1½ stops	NR	NR
Ektachrome 160, type B	None	None	CC10R	1 stop	CC15R	1½ stops	NR	NR
Ektachrome 160, type B Prof.	None	None	CC10R	½ stop	CC10R	1 stop	NR	NR
Ektachrome 200	None	½ stop	CC10R	1 stop	CC10M	1½ stops	CC10M	3 stops
Ektachrome 200 Prof.	None	None	CC10R	½ stop	NR	NR	NR	NR
Ektachrome 400	None	None	None	½ stop	CC10C	1½ stops	CC10C	2½ stops
Kodacolor 400	None	None	None	½ stop	None	1 stop	None	2 stops
Kodacolor II	None	None	None	½ stop	CC10C	1½ stops	CC20C	2½ stops
Tri-X (B-and-W)	—	None	—	1 stop	—	1½ stops	—	2½ stops −20% dev.

NOTE: The information in this chart is approximate, and was compiled from several sources.

*Stopping action when using relatively slow shutter
speeds is mostly a matter of timing. The hand paused
for a split second at the peak of the throwing motion
and is sharply defined at 1/125 sec.; but this shutter
speed was too slow to "stop" the birds, which are
therefore a little blurred. Tri-X film; 200 mm lens.*

SUBJECT MOVEMENT

Shooting with slow shutter speeds, as is often necessary in dim light, can cause problems when photographing moving subjects. When you are squeezing out the last bit of film sensitivity by shooting wide open, you do not have any margin left to adjust for subject movement. You have probably heard that 1/125 sec. will stop most kinds of action with a normal lens. But that is a fast shutter speed compared to the usual low-light speeds of 1/30 sec. and slower.

You might be surprised to learn that a relatively slow shutter speed can arrest subject movement. Generally speaking, a man or a horse walking at a right angle to you, and more than about 12 m (40 feet) distant, can be stopped by an incredible 1/30 sec. If the subject is closer than that, one stop faster speed is required—1/60 sec. If the subject is moving directly toward you, one stop slower shutter speed—1/15 sec.—can be used.

It is apparent that the real problem when shooting moving subjects is not the movement of the subject, but more often the movement of the camera.

Of course, these figures are only estimates and will vary according to specific conditions. It is best to test several situations and shutter speeds, using the information here as a guide. You will want to keep accurate notes so that you can determine your own limitations.

Time your shots to coincide with peak action; for instance, when the subject has reached the top of a jump. Try panning—that is, moving the camera with the moving subject—and you will again be surprised to find the relatively slow shutter-speed requirements. Remember, your biggest concern will be camera movement, not subject movement. Re-read Chapter 4; it will give you a lot of help in this regard.

The accompanying table indicates some average
kinds of subject movement and the shutter speeds needed
to "stop" the motion.

SHUTTER SPEEDS FOR SUBJECT MOVEMENT

Action	Slowest Shutter Speed with 50 mm Lens at Approximately 25 Feet	Slowest Shutter Speed with 50 mm Lens at Approximately 40 Feet
Walking	1/60 sec.	1/30 sec.
Swimming	1/60 sec.	1/30 sec.
Running	1/125 sec.	1/60 sec.
Skating	1/250 sec.	1/125 sec.
Cycling	1/250 sec.	1/125 sec.
Ocean waves	1/250 sec.	1/125 sec.
Horse race	1/500 sec.	1/250 sec.
Automobile	1/500 sec.	1/250 sec.

NOTE: This chart is approximate but works most of the time. Remember that the closer the
subject gets to the camera, and the longer the lens, the faster the shutter speed needed.

100

9

How to Simulate Natural Light

It may seem inappropriate to discuss supplemental artificial lighting in a book about low-light photography, but the subject really is not out of place. You want to get pictures in low-light conditions, and sometimes those very conditions make it impossible to get the photograph you really want. In fact, you may be forced to add light to get any picture at all. But you still want the resulting photograph to look and feel as though it had been shot in natural light.

There are several techniques and light sources that can be used to imitate natural light. The ones you choose will depend on the time of day, the kind and amount of existing artificial light in the area, and the kind of film being used. Consider the following supplemental light sources and the conditions under which they can be used.

BOUNCE ELECTRONIC FLASH

Any time the existing light is exclusively daylight, you can use bounce strobe (electronic flash) to lift the level of light without destroying the soft quality of the diffused daylight or the color balance of the existing light.

When there is a need to raise the light level or to re-place existing *artificial* light, bounce flash can be used and

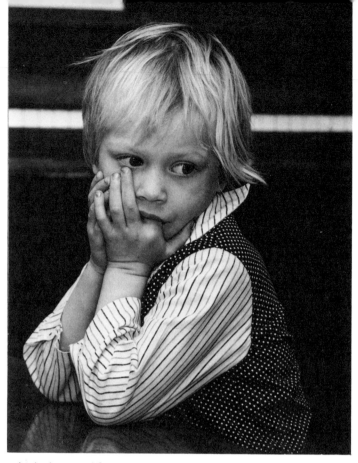

Light bounced from a corner, as explained in the text, provided natural-looking illumination for a pensive mood (see diagram, opposite page). Electronic flash. Plus-X film.

still give the effect of normal room lighting. In these cases, the color balance would be a problem only if the output level of the flash were equal to, or less than, the output level of the artificial light in the room. Some overlapping of incandescent light with electronic flash is usually not objectionable, for it will tend to add a little warmth to the scene.

It is possible to match the color of light accurately in almost any situation when using electronic flash if corrective filters are placed in front of the flash reflector. An 85B

filter or gel taped onto the front of the flash unit will correct for regular household incandescent bulbs. Thus the flash unit becomes an accessory light source compatible with "indoor" film. Now you can shoot with tungsten-balanced type B film and have proper color balance. It is best to use black photographic tape to attach the filter to the flash, to block out any extraneous light that might otherwise taint the color balance. A gelatin filter 76 mm (3 inches) square fits most flash units better than a regular round glass filter, but either will work.

Fluorescent lights are, however, horses of a different color. These lights defy cancellation, and almost always introduce a green tint to any situation of light or type of color film. Fluorescents and other problems will be discussed later.

There are many ways to use bounce flash. The best all-around technique is to aim the flash backwards into a corner that is behind you as you face the subject (see the accompanying illustration). Aim the flash so that it hits the junction where walls and ceiling meet, allowing both to

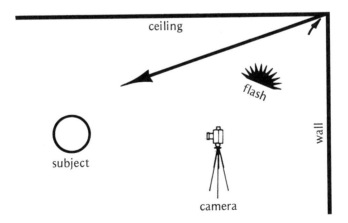

act as reflectors. Of course these surfaces should be white, off-white, or neutral—colored surfaces will affect the color-cast of the subject. The light that bounces from this arrangement is very soft and looks natural because it provides soft directional and fill lighting from one light source.

A wall surface alone also works quite well as a bounce reflector, but there is less fill light, and so more subject shadow falls on the opposite wall (see the accompanying illustration).

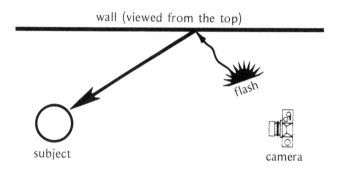

wall (viewed from the top)

flash

subject

camera

An umbrella, a flat screen, or a white card is similar in effect to a wall, although light from any of these is less soft and more directional. Each offers greater control in positioning, however, and all three are portable.

The ceiling in front of the photographer, in between the flash and the subject, is often used for bounce flash when no wall is close enough to the subject. However, the light hits the subject from a higher angle and usually causes dark shadows in the eye sockets. Many photographers minimize this effect by taping a white card or a spoon to the flash to reflect some of the light directly into the subject's face, especially the eyes.

wall (viewed from the top)

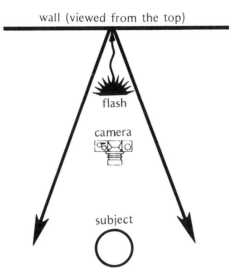

flash

camera

subject

All these flash techniques call for a method of accurate exposure calculation. This can be done with a flash meter, an automatic flash sensor, or a guide-number or a flash-output table.

Calculation for complete replacement of the existing light is fairly simple for all systems. With a flash meter or with automatic flash, you merely shoot with the indicated reading. With use of guide numbers or a table, you determine the distance from flash to bouncing surface to subject, then open up two stops from the reading shown for that distance.

An example using the guide-number system might be something like this: Your subject is 3 m (10 feet) away from the bounce surface and the flash is 1.5 m (5 feet) away. The total flash distance would be 4.6 m (15 feet). If the guide number were 165 (for ASA 200 film), you would divide 165 by 15 and so calculate an f-stop of $f/11$. Then you would open up two stops for a bounce shooting f-stop of $f/5.6$.

The options get somewhat more restrictive when you merely want to boost or fill in the existing light. Here you run into an interesting problem—most of today's electronic flashes are too powerful for this kind of situation. Remember, you have to put out less light than the available-light reading of the room, and the shutter speed should not be below 1/30 sec., nor faster than the top flash-synchronized shutter speed (in most cameras this is 1/60 sec., although some go as high as 1/125 sec.).

Calculations for the aforementioned flash unit would be worked out like this: Using the prior calculation for a working flash f-stop of f/5.6, you would have to use a shutter speed of 1/4 sec. with ASA 200 film to expose properly for the existing light at that aperture setting. However, such an extremely slow shutter speed would cause a ghost image with electronic flash. It would therefore be necessary to cut down the output of the flash in order to raise the shutter speed by at least 3 stops to 1/30 sec. (1/60 sec. would be better). This would open the aperture to f/2. Now do you see the problem? Using the flash unit as is would overexpose the film by 3 f-stops. A regular handkerchief can solve the problem. First, turn the automatic flash to its manual setting. Then cover the flash reflector with three folds of the handkerchief (one fold for each f-stop) to get a working flash f-stop of f/2. This will permit a shutter speed of 1/30 sec. Of course, it would be better for you to test this procedure with your own equipment—and your own handkerchief. You could speed things up and save some film by borrowing a flash meter for the initial tests.

DIFFUSION-SCREEN WITH FLASH

Shooting electronic flash through a translucent material produces a fairly soft light similar to bounce flash.

This old 22 in. floodlight reflector for incandescent (tungsten) bulbs gives beautifully soft, diffused light when covered with several layers of white cloth.

To be most effective in creating soft light, the diffusion screen should be quite large (about 46 cm [18 inches] in diameter), and positioned at least 30 cm (12 inches) from the flash tube. Again, you can correct the color balance of the flash to match the existing light. A flash meter is a necessity here, for there is no way to determine the exact output of the screen-and-flash combination without it.

PHOTOFLOOD LAMPS

It is possible to use flood lamps in much the same way you would an electronic flash unit. Use them direct or bounce them off ceilings and walls. There is the advantage of being able to see the actual lighting before exposing the film. There is no problem in matching color balance with type B film, nor are there restrictive shutter-speed/aperture combinations. Just take a reading and shoot according

107

to what the exposure meter indicates; this will depend on the exposure system you use.

One of my favorite semi-studio light sources is a large 56 cm (22 inch) aluminum bowl reflector that has several layers of white translucent acetate cloth in front of a 100-watt light bulb. This light produces, in a room, soft light that looks very much like natural light.

One word of caution: Be careful when using incandescent lights as the supplemental light source. Watch for daylight spillover or leaks. Daylight will cause unattractive blue coloring in your subject (with indoor film, of course).

EXISTING-LIGHT REFLECTOR

A reflector such as a white card, Reflectasol, or even a sheet of newspaper, can be used to reflect existing light back onto the subject. In low light, however, reflectors have limited use, for the light is usually too dim to be seen when bounced off a reflector. But, if it must be used, you can ask the subject to tell you when the reflector looks the brightest, and then shoot.

Granted, auxiliary light sources create less than a strictly natural situation, and when you use them, people become very much aware of your presence, reacting differently than they would if you were shooting quietly from some dark corner. Then again, in situations of highly involved activity, such as a party, extra light sources may be acceptable and even go unnoticed. The key to getting natural photographs in this kind of situation lies in the personality of the photographer.

10

Black-and-White vs. Color

Though most photographers these days seem to prefer color to black and white, there is still much to recommend in monochrome. Actually, both have advantages.

The simplicity and abstract possibilities of black-and-white photography can make it a profound, symbolic form of expression. Black-and-white photography is something like a radio play. You can use your imagination. Your mind can invent the colors and color relationships to fit your feelings of the unique moment. This quality is a real advantage in low-light photography, which depends on impressions for its effect.

In the darkroom it is easier to manipulate black-and-white prints than color prints—although that margin is narrowing fast. Still, many of the greats of interpretive photography prefer black-and-white—from Ansel Adams, the master of the creative landscape scene, to Jerry Uelsmann, the "magic realist" who creates a fantasy world that is in some ways more real than the physical world.

Black-and-white printing allows you to concentrate on the content and design, the form, and the geometry of a subject without being distracted by color. You may have noticed that when you are caught up in the real drama of a living experience you are not aware of *color*; yet, when you see a dramatic movie you are very much aware of *the*

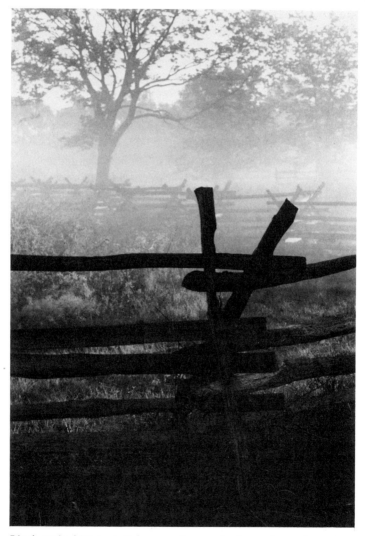

*Black-and-white materials can enhance photographs made under a
number of special lighting conditions, including the muted tones
of this misty morning in Illinois. Plus-X film; Nikon F camera.*

colors. I believe that we take our everyday experiences so much for granted that we do not really see the colors around us until our attention is called to them, while we see colors and admire them when they appear in a photograph or on the screen. That may be one of the reasons that black-and-white photographs seem closer to reality.

Don't get the idea that I do not like color. It would be more correct to say that I prefer black and white to color in some instances. On the other hand, there are times when I prefer color. Before you throw up your hands in despair, let me explain.

For me, comparing color photography to black-and-white photography is a lot like comparing steak to blueberry cheesecake. I love them both, but steak has its moments of preference, and cheesecake has its. The moments do not coincide, and I would not trade one dish for the other.

Color has emotional cues that are different from those of black and white. Color can do things that monotone cannot: It can compare or contrast hues, evoke color-connected feelings, and compress many colors into a unit that vividly shows its separate parts. Color can express feelings without visual recognition of content.

This is a world of color emphasis. Almost everything that is bought or used is covered with colored stickers, pictures, and lettering. Low-light candid photography in color is becoming quite commonplace.

PRACTICAL CONSIDERATIONS

Black-and-white images and color images are previsualized in different ways. It is therefore difficult to carry two cameras and to shoot the two kinds of film on the same occasion. Each takes a different emotional and technical attitude, or set.

111

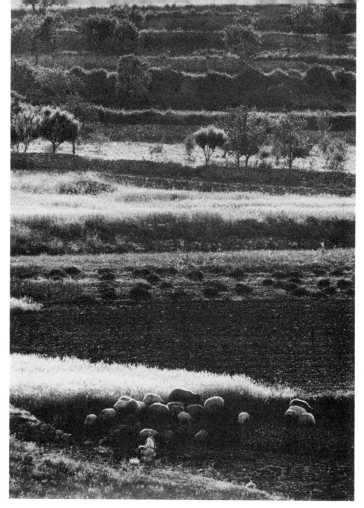

Black-and-white clarifies tonal contrast between overlapping strips of fields and trees. A long lens (200 mm) intensifies the striped effect by "compressing" distance. Ilford HP4 film; Nikon F camera.

Black-and-white shooting requires you to look at relationships of tones and forms in terms of gradations of gray. This is a completely different frame of reference from that governing the manipulation of associations of color. Detail and sharpness seem to have more importance in black and white; subtle nuances of hue are important in color.

112

11

Specialized Equipment

This book has played down the use of specialized equipment in the belief that neither the average photographer nor most professionals really need it to get good photographs when the level of available light is low. There are times, however, when a special piece of equipment can give you the advantage in getting a great low-light shot. Here are a few such useful items.

A HEAVY TRIPOD

A tripod is not really a specialized piece of equipment for many photographers. But a solid, heavy-duty tripod is not the usual thing. A large, strong tripod is more adjustable and easier to use. It can get you closer to the subject without falling over, and it gives rock-solid support for long, timed shots. I look at it this way: Most of the time I do not want to be bothered with a tripod because it gets in my way, it gets in other people's way, and it is an added burden. But if I really need a tripod, I want it to be solid and usable.

A LONG CABLE RELEASE

Normal-length cable releases often cause camera movement by transmitting the push or pull of the release

This well-built tripod is only 8½" (21.6 cm) long when folded, yet extends to a sturdy 22" (56 cm), the right height for eye-level shooting from a kneeling position. It could convert anyone who thinks tripods are too inconvenient. It can even be used as a chestpod. Made by Gitzo in France.

mechanism to the camera. A long cable release is better because it absorbs any hand movement more effectively. I prefer the air-type plunger cable release with the extra-long flexible rubber tubing. This kind of release has several advantages—it transmits the least amount of movement of any cable release; it can be cut to any length; the air bulb can be squeezed easily in the pocket (for those supercandid shots described in Chapter 12); and it can be stepped on to provide a hands-off technique. (For instance, you could place your camera on a tripod, put your hands behind your neck, lean back, and shoot photographs of people without their having the slightest indication you were doing so.)

Similar to the cable release, a remote-control device offers even more freedom and versatility. While such a device is a very specialized piece of equipment, and quite expensive, it provides remote-control photography for those occasions when all else fails. This device makes it possible to photograph subjects at great distances from you and the

The bulb forces air down the tube to trip the shutter. This device is gentler than the standard cable release, and more flexible.

camera. You could even photograph yourself at some distance from the camera: Just think of the savings in models' fees! Seriously, some professionals have used remote controls while standing in as models themselves.

MOTOR DRIVE/POWER WINDER

The accolade for the most useful accessory for low-light photography would have to go to the motor drive. This marvelous piece of equipment can enable the photographer to catch all the nuances and sudden changes of expression and action of the subject—and in rapid sequence. Also, it helps to steady the camera for those extra-slow shutter speeds often necessary in low light, by providing more mass to absorb shutter and camera movement. The added weight also settles the camera more solidly in the hands. I even use a motor drive on a copy stand; it is convenient and, because it helps reduce camera motion

caused by hand release of the shutter, it makes possible tack-sharp results at very slow shutter speeds.

ZOOM LENSES

A zoom lens has a decided advantage when you cannot move yourself but want to crop the image. It also gives you instant choice of several focal lengths. Probably the best zoom combination is one that covers the range from a wide angle to medium-telephoto length, such as a 35 mm–85 mm. There are lenses like this available with a maximum aperture of $f/2.8$, which is extremely fast for a zoom lens. Such a lens would be adequate for most low-light conditions. With a system using this kind of lens, you would not have to carry two camera bodies or an assortment of lenses; one camera and one lens would do it all. However, I would still stick that superfast little 50 mm $f/1.4$ lens in a spare pocket, just in case.

There may be other useful accessories that have not been mentioned, but the items mentioned here and in some of the other chapters will get you through almost any situation. Remember, the image originates with the photographer, not with the equipment. Using a little imagination and some ingenuity, you can improvise enough to meet most special needs and emergencies.

12

Techniques for
Candid Photography

It is important to me to preface this chapter with a few personal thoughts about integrity and human decency. Even though candid techniques are sometimes necessary to get spontaneous photographs, I feel that the photographer should always be aware of the rights and feelings of others. If there must be a choice between not getting the picture and causing distress or harm to the subject, the photograph should not be taken. This responsibility applies to both the taking and the using of photographs.

This does not mean that you have to be afraid of shooting interesting candid subjects. Some of the techniques described in this chapter will permit direct photographic approach without disturbing the subject. Do not be too concerned, though, if you get an occasional tomato thrown at you because you miscalculated the situation. Just be sure it doesn't hit the camera.

Through the years, photographers have used an amazing variety of techniques and equipment to get candid photographs—including tiny cameras built into tiepins and watches, and supertelephoto lenses. They have also used a variety of bizarre personal techniques to get natural-looking candid photographs. Most photographers are not so inventive, however. They inadvertently call atten-

Because a 200 mm telephoto lens was used, this Middle Eastern woman was not aware of the photographer.

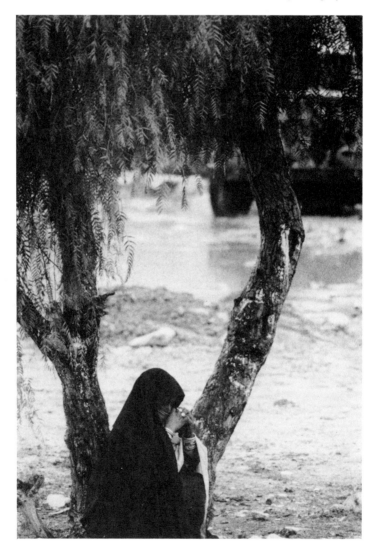

tion to themselves and alert the subject to the fact of being photographed. Of course, the natural situation then disappears.

Here are a few techniques to help you go relatively unnoticed by candid subjects.

THE CASUAL APPROACH

You have to be a fairly good actor to pull this one off. You must act as though you are not interested in the subject. Do something else or look at other people while

Impressed by his wife's thoughtful mood, the author quickly grabbed one shot with a 200 mm telephoto lens before she saw him and smiled, changing both expression and mood. Tri-X film; Nikon camera.

Mother and son share an instant of introspection, neither aware of the other's momentary solitude. Seconds later, the festivities of a family Christmas dinner prevailed. Sitting quietly on the other side of the room, the author was able to make the photograph without disturbing them.

you position yourself to shoot. Try to watch the subject with your peripheral vision so as not to signal your intentions with guarded looks or direct stares.

When things look right, shoot quickly, then return to your nonchalant attitude. The process goes something like this: Bring the camera up to your eye at the same moment you turn to point it at the subject; shoot without hesitation, then immediately return the camera to its resting position and look away. All this must be done smoothly, casually, and very quickly.

Most of the time, even if you are seen, the subject will not be disturbed, for things will have happened so

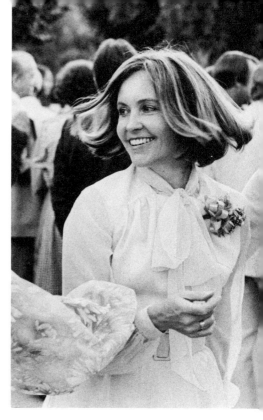

Presetting the exposure and prefocusing the lens made it possible to capture this happy recognition of a friend at a garden party (half frame). Ilford HP5 film, ASA 400; Contax RTS camera; 85 mm lens.

rapidly that he or she will not even have realized that a photograph was taken.

In this, as well as in the techniques that follow, it is essential to have your camera preset for exposure and focus. Prefocus on an object that is at the same distance as the subject but in another direction. Preset the exposure by metering a similarly lit area.

THE QUICK SHOT

This technique is much the same as the casual approach, but the emphasis is on speed. It is possible to walk right up to the subject and deliberately and rapidly shoot a photograph without causing much concern. If you act in a professional way throughout, staying calm and confident,

121

the subject will probably not get ruffled. Be sure to turn your attention elsewhere immediately following the shot.

THE DISARMING SMILE

This may seem ludicrous, but it is possible to smile at your subject while photographing him or her and thereby maintain an atmosphere of calm and friendliness in an otherwise hostile situation.

I was photographing a group of Arab women in a cemetery when one of them spotted me and approached, shouting angrily. I smiled at her broadly and said, "Ma Salaam," which means, "Peace be with you." She kept shouting, and I kept smiling and saying, "Ma Salaam." Finally, she smiled and let me take as many photographs as I wanted. Usually people will respond warmly to a friendly or persistent smile.

The disarming smile works equally well after you have been caught taking the picture, especially after the quick-shot technique. A smile can help you approach the subject for an intimate, warm close-up. It is most important to be genuine and natural, and a touch confident. If you really like people, and show it, they won't mind being photographed.

THE SIDE SHOT

A fairly clever diversionary technique, the side shot leads attention away from the camera and many times permits the subject to be photographed unaware.

While standing at a right angle to your subject, hold the camera vertically to the right side of your face, so that you can just barely see through the viewfinder out of the

Face one way and point the camera another. With practice you learn to see through the viewfinder from the corner of your eye.

corner of your eye. Look straight ahead, glancing over at the subject through the viewfinder only long enough to frame and shoot.

There are mirror attachments that can permit you to shoot at an angle, but this reverses the image and makes it difficult to line up the shot.

THE WAIST-LEVEL VIEWFINDER

Some cameras have waist-level viewfinders or removable pentaprisms to permit waist-level viewing. With this kind of camera slung on its strap around your neck, you can point the camera by moving your body and fire the shutter with your thumb. Most of the time, no one even notices what you are doing.

123

Cameras that have removable pentaprisms can be used at waist level. A cable release, or a hand casually draped over the camera with thumb on the shutter release, make it easy to shoot unnoticed by the subject.

With a long air-type cable release you can put your hands in your pockets and shoot without anyone knowing what is happening. Couple this with the use of a power winder or motor drive, and you have the ultimate equipment for candid photography. You can even make a series of shots without taking your hands out of your pockets—very natural!

WIDE-ANGLE LENS SHOT FROM THE CHEST

This is similar to the waist-level technique, but here you use a wide-angle lens. This permits you to shoot without a waist-level viewfinder—even without looking at the camera. Naturally, you will have to experiment with your camera to see what is the best height at which to hang it

This shot was grabbed quickly. Then, before the author could move to a better-lit angle, the man stood up and the mood was gone. Agfapan 400 film; Nikon F camera.

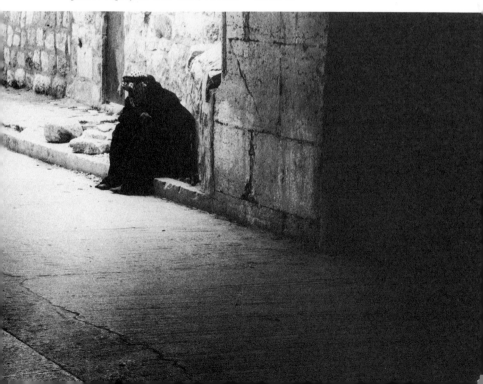

around the neck, and which lens to use. With extreme-wide-angle lenses it is possible to walk up next to the subject and shoot without being noticed if you are careful to mask the sound of the shutter and motor drive by firing when there are other sounds that will cover those your camera makes.

TELEPHOTO LENSES

The natural solution to candid photography would seem to be the telephoto lens. While it is true that you can get excellent close-up candid photographs with this type of lens, you may be surprised at how readily it draws the attention of remote subjects; so even if you use a telephoto lens, practice some of the techniques mentioned in this chapter.

I have found that the best telephoto shooting situation is a position high above the subject—a high wall, a balcony, or the like. People usually do not look up, and you can literally "shoot fish in a barrel."

CAMOUFLAGE

This technique is self-explanatory—you hide yourself from the subject. This can be done by poking a lens through some bushes, or peeking around or above a wall. A car is a great place to conceal yourself as you shoot. You might also try a window of a house—just make sure it is open, so that you do not get reflections or an image degraded by dust.

Facing page: *A telephoto lens caught this elusive subject just before he turned on his heel and strolled away. Tri-X film; 75—150 mm zoom lens; Olympus OM-2 camera.*

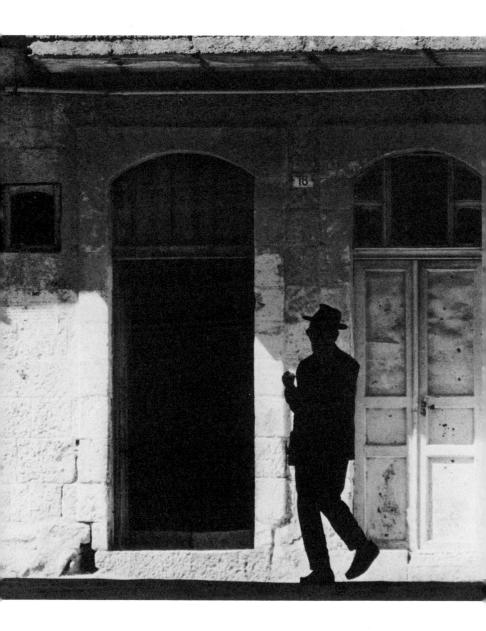

The word of caution here is: Don't let the subject see you because it will be obvious that you are being sly—and that will probably not be considered endearing.

As I said in the beginning, I hope that you exercise human kindness and respect for the feelings of those you photograph candidly.

A house in rural Utah was photographed under an overcast sky on Ektachrome film; no filter was used. Notice the great depth of field provided by the 35 mm wide-angle lens. Nikon F camera.

Because the sheep were backlighted by Jerusalem's early-morning light, the author used the highlight exposure system (explained in Chapter 6). It told him to underexpose the Kodachrome 64 film by one stop. Olympus OM-2 camera with 21 mm lens.

The monochromatic tones of an overcast, rainy day tell us that Paris can provide solitude and quiet. Shooting without a color-correction filter helped emphasize the cool, muted tones. 35 mm lens; Nikon F2 camera; Agfachrome film.

The bluish cast of deep shade was corrected for Kodachrome 64 film with an 81A filter: Notice the correct neutral-white rendition of the background. Metering was done with an averaging behind-the-lens meter, reading off the skin. Contax RTS camera with 85 mm "portrait" lens.

Very dim window light and hand-held shooting conditions made this a difficult shot, but diffused daylight on the subtly patterned oriental carpets in this mosque heightens the atmosphere of religious devotion. Use of a wide-angle lens adds to the feeling of space and tranquillity. Exposure was metered from rugs, using the Nikon F's behind-the-lens meter. Agfachrome daylight film.

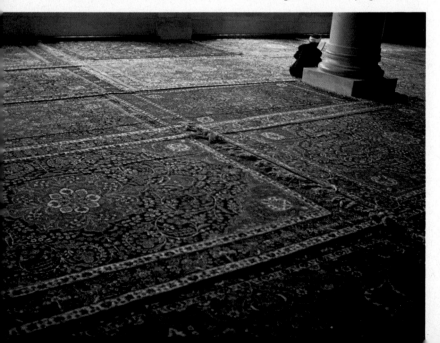

The approach to the formerly "lost" temples of Petra, in Jordan, is through a narrow gorge whose height calls for use of a 25 mm wide-angle lens. In order to capture the change in color balance from bluish in the shade to warmer tones where sunlight touches the end of the pass, the exposure (for Kodachrome 64 film) was determined by taking a close-up reflected-light reading of the stone in bright light and then under-exposing one stop. Contax RTS camera.

Intricately patterned tilework on the Dome of the Rock mosque in Jerusalem is worth a close-up look with a 200 mm lens (Nikon F camera). The delicacy of the colors would have been destroyed with the slightest underexposure; in fact, a half-stop extra exposure was given beyond the reading indicated by the behind-the-lens meter.

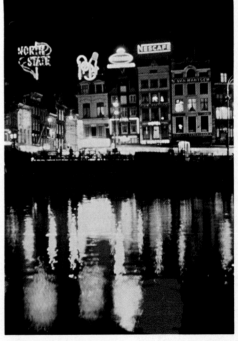

The reflections of one of Amsterdam's night streets illuminate a canal. Timed exposure. Nikon F camera with 50 mm "normal" lens.

Strong midday sun above this tent projects the tent's bright, warm colors onto the audience, adding an unusual glow to dedication ceremonies at Nauvoo, Illinois. A reflectance meter was used to take a reading from the backlit tent, then one stop underexposure allowed.

The garish colors of this restored trolley car are intensified by late afternoon light and one f-stop underexposure. The film was Ektachrome 200. The light was measured with an incident-light meter (as explained in Chapter 6). Photographed at Trolley Square, Salt Lake City, Utah. Contax RTS camera with 85 mm lens.

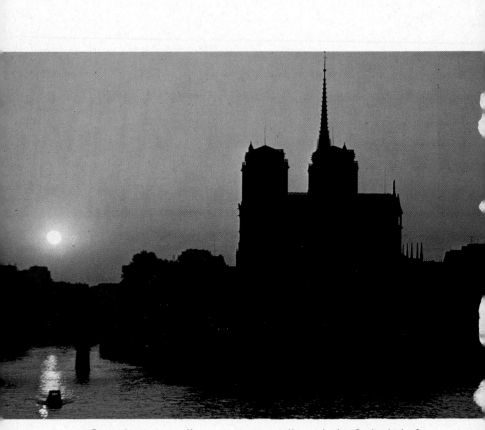

Paris shows up well at sunset, especially with the Cathedral of Notre Dame silhouetted above the glowing Seine. This traditional pictorial shot was made on Kodachrome 64 film, using an 85 mm slightly-long lens on an Olympus OM-2 camera. Exposure was determined by using the camera's built-in meter on the sky, then closing down one-half stop.

13

Composition in Low Light

Any arrangement of the elements within a picture can be called "composition." But definition of *good* composition goes further: a *pleasing* arrangement of the elements within a picture. Although "one man's meat is another man's poison," as the saying goes, there are some universal standards that generally hold true. Knowing these standards or "rules," we can point ourselves in the right direction—remembering, that these so-called rules fluctuate and change from time to time. You can sometimes rebel against present standards and still achieve good composition.

A good composition helps the photograph make an understandable statement about the photographer's feelings and the concept he or she was trying to communicate. Most people are moved and impressed by photographs that have well-designed compositions with clearly defined messages. This is true even when they cannot explain the composition or message; they may feel it without being able to articulate their feelings. Not only is a good composition *good*, but it also "feels right." A commercial artist once told me that a design that did not work made him feel uncomfortable.

The general, yet important principles of composition and design discussed in this chapter are not intended

129

Simplicity can apply to pictorial organization, as at left, where the archway holds diverse elements together, or to subject matter, such as the everyday scene below. Timing is important, too. At left, it meant waiting until the right figure arrived at the right spot. Below, it meant working quickly before the dog woke the child, and the picture's geometry echoes this: See how the strong, restful horizontal lines are crossed by diagonals, hinting that repose is only temporary. The staircase is in the Boston Public Library, McKim, Mead and White, architects. (Both photos © Liz Burpee, A.S.M.P.) Minolta cameras.

131

Above: *This extremely simplified view of Zurich has just enough detail to give information. The bird adds accent and balance. Plus-X film at ASA 200; 200 mm lens on Nikon F camera.*
Facing page: *Only the geometric shapes of this fogbound Mormon temple remain. Tri-X film; Nikon F camera.*

to be the last word. They are only guidelines; you can change them or ignore them if you want, but be sure that your resulting composition feels right.

Here, then, are some of the principles of good compositon, with occasional comments about how they apply to low-light photography.

SIMPLICITY

Anything that does not add to, or is not an important part of, the composition should be excluded. Change your angle of view, move in closer, or use selective focus to eliminate distracting objects that add nothing to the concept or design. Do not let the background show clutter. Low light can be an advantage in this regard, for it is usually diffuse and shadowy and tends to eliminate detail, thereby simplifying the final image. A graphic example would be a fogbound scene.

You can help yourself to see the simplifying features of low light by using a couple of tricks. You can simulate what the film will record by squinting your eyes while looking at the subject. Another way to do this is to look through the viewfinder while stopping down the camera lens with the depth-of-field preview button. Many cinematographers carry a neutral-density viewing device for the same reason. These techniques help your eyes see what the film will record. Your eyes alone are much more sensitive than the film, and you can see into shadow areas that the film cannot record.

Cropping is an important technique to simplify composition. You do not always need to show the whole subject to make a complete statement about it. Quite often a part of the subject is much more expressive than the whole. Tight cropping can sometimes strengthen relationships of form and content; geometric shapes and lines can be united with more intimacy.

Tight cropping focuses attention on the bus's grille and destination signs. Tri-X film; 85 mm lens; Olympus OM-2.

Make yourself a pair of cropping "Ls" from some black cardboard. Each side of the "L" should be about 25 cm (10 inches) long and about 38 mm, (1½ inches) wide. Put the "Ls" together to form a rectangle or square shape, with an opening in the middle. Put the "Ls" over your picture, then adjust and readjust the area they frame. See if you can find several good compositions as you move the "Ls" around, then try to find one that is simpler, yet more expressive than the original format. This exercise will help you develop a keener sense of composition.

DOMINANCE

The subject of the photograph should stand out from the surrounding elements and be of central interest. Theme or concept and subject matter should be dominant. This can be accomplished by contrast of size, tone, color, texture, motion, or content, or in a number of other ways. A simple background adds to the dominance of the chosen

subject. In low-light photographs, shadows and dark values often fill large parts of the picture area and will steal dominance from the subject if not carefully positioned. By moving the camera position, or the subject, it may be possible to create backlight or sidelight, which will give the needed separation. Or perhaps you can reposition to get a light background or a contrasting color or value. If you can arrange the background for separation the characteristics of low light become an asset, for those same dark areas can now simplify the composition and help the subject dominate the image.

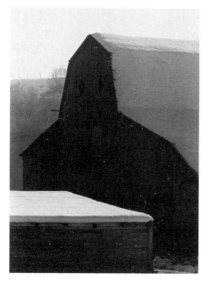

There is no doubt about which elements dominate this tightly cropped barn scene. Plus-X film; 200 mm lens; Nikon F camera.

UNITY

This term describes the integration of all the parts of a picture into a complete, working whole. To accomplish this unity you must be sure that the secondary elements of the picture are appropriate to and support the

dominant subject, or center of interest. This can be achieved by harmony or by contrast. Repetition and alternation of a pattern or theme can also help to relate all the separate parts of a picture. The idea and message of the photograph should be in harmony with all the other elements of it. For instance, you probably would not want to photograph a beautiful woman in a situation that would make her appear unattractive by association or contrast.

The curves in the tree and in the horse's neck, emphasized by the backlighting, echo each other and unify this rural scene.

A more or less even distribution of the mass and "weight" of objects in this photograph of a graveyard make it a conventionally balanced picture. Tri-X film; Nikon F camera.

BALANCE

This has some similarities to unity but is a bit more specific. Balance is concerned with the distribution of elements within the picture area. The "weight" of these elements should be balanced so that the picture does not appear lopsided or unbalanced. This is not to say that you should center the subject in a static position. It does mean that placement that *feels comfortable* should be used. Perhaps this all seems a bit vague, but rules that are too hard and fast bring rigidity and staleness to the art.

Some of the ancients tried to pinpoint the placement of an object to accomplish balance, but theirs is, at best, only an approximate solution. The Golden Section, developed by the Greeks, has been interpreted to imply that a main subject should be placed or divided approximately a little more than one third along a horizontal line. Similar to this is the "rule of thirds," which divides the picture area into thirds both horizontally and vertically and

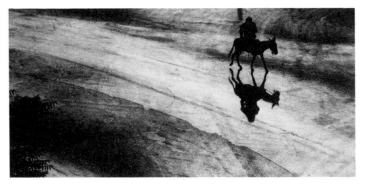

Although not balanced according to conventional rules, this picture of a man on a donkey in Israel has balance provided by contrasting shapes. Tri-X film; 200 mm lens; Contax RTS.

places the center of interest at any of the four resulting intersections.

Please accept these so-called rules only as suggestions and approximations. Sometimes an extreme variation from the norm will give the most exciting results.

CONTRAST

Contrasting elements bring attention to their differences, making one or the other, or both, stand out. A red ball against a pale blue wall is a vivid color contrast. A smooth object in front of a textured background emphasizes contrast of texture. A Volkswagen in a parking lot full of Cadillacs points up an economic contrast.

Contrast of color or texture is a little difficult to achieve where the lighting is soft and even. Here, objects tend to flow together in value. You have to be alert and careful in using this quality of light. Also, you should re-

The white hat is the subject, and contrast makes it stand out. The flowing lines soften the stark contrast and complement the small dark profile.

member that your eyes see much more than the film can record.

As described above, squinting your eyes to see only the most prominent areas will help you see the detail that the film will record. Stopping down your lens with the depth-of-field preview button will give you the same kind of simplified view.

ACCENTS

Sometimes just a small accent on a repetitious pattern will bring the whole subject to life. Although similar to contrast, accent is not as strong. It is the little added touch that makes the composition sing. Imagine a shepherd silhouetted against the Jerusalem sky. He holds in his hand a staff that is visible only because of a thin, faint rimlight on its edge.

Accent breaks up the solidarity or weight of the subject and provides a focal point or diversion. Accents are especially important in low-light photography because of the abundance of large detail-free areas these photographs usually include.

A farm road in northern Utah is strengthened by the small rim-lit accents on horse's mane and roadside weeds. Exposed according to substitute reading of near portion of road. Plus-X film; Nikon F camera with 200 mm lens.

DEPTH

Depth is an important illusion of distance that adds dimension and reality to the otherwise flat images of photography. Converging lines, like railroad tracks, create a feeling of advancing into the picture area. Overlapping objects or things in the foreground that make a frame for the scene add to the illusion of depth. Even dark, silhouetted foreground shapes in low light add dramatically to the feeling of perspective.

141

Look for objects with which to frame the subject; they can be on top, to the side, around, or in front of the subject. Try tree limbs at the top of the picture, bushes or buildings at the side, a window frame around, or a grill-work in front. These are all framing devices, and they can be very useful to create a three-dimensional feeling in photographs.

Below left: *Converging center lines give an illusion of depth, emphasized by wide-angle lens. Behind-the-lens averaging-meter reading. Tri-X film. Nikon F camera.* Below right: *The curled iron lamppost frames top and side of this study of an old Parisian building. Plus-X film. Nikon F camera with 200 mm lens.*

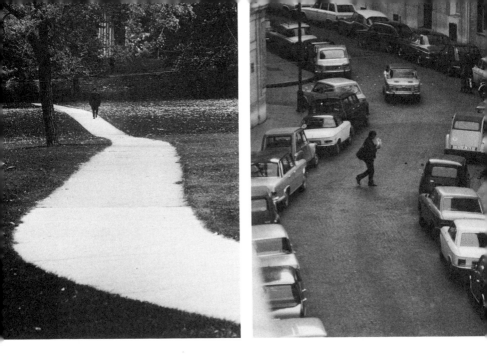

Above left: *The path leads the eye to the pedestrian. Substitute reflected-light meter reading of grass.* Above right: *This busy portion of a Paris street forms an "S" curve. Averaging-meter reading of the street.*

LEADING LINES

Most good photographs have lines or shapes that lead your eye into the picture area and on toward the subject. These are called *leading lines*. They can be literal or implied, visually or psychologically. They can be either a single object or line or parts of several. The classic "S" curve is an example of a leading line. Hands reaching toward a face lead your eyes to the face. A mother's bending figure leads your eyes to the child she is watching over.

VALUE AND TEXTURE

Value and texture are surface qualities that show the outward structure of an object. The dark and light qualities of tonal value can represent form and shape and give variation to an area. Texture can give a sense of touch and reality to a photograph. Value and texture help create an illusion of form and depth when used properly.

Thoughtful use of the available light can enhance or destroy fragile tonal values: Soft, even light encourages the reproduction of a wide range of values; harsh, direct light destroys the gradual variation of tones.

The texture of the rough-edged light-colored leaves contrasts with the smooth curves of the stark black tree trunks. Exposure determined by incident-light reading. Photographed along the Susquehanna River in Pennsylvania. Tri-X film; Nikon F2 camera.

The black wedge shape of the man's long garment accents the many shades of gray in this Jerusalem mosque wall. Use of a wide-angle lens (25 mm) exaggerates the viewer's sense of space. Tri-X film; Contax RTS camera.

GEOMETRIC SHAPES

My favorite compositional gambit is to look for large geometric shapes, real and implied, that will simplify the picture structure. The squinting-eye trick allows me to locate these larger-than-life shapes within the frame. A harmonious integration of large geometric shapes will give unity and coherence to the picture. I especially like the contrast of a triangular shape with a round shape.

Above: *Haystacks balance each other in near-abstract geometry. Photographed in northern Utah on Tri-X film exposed by reflected-light reading plus a half-stop; Nikon F camera.*
Right: *A crowd drifts into near-geometric formations. Agfapan 400 film was used with a 200 mm lens on a Nikon F for this Jerusalem street scene.*

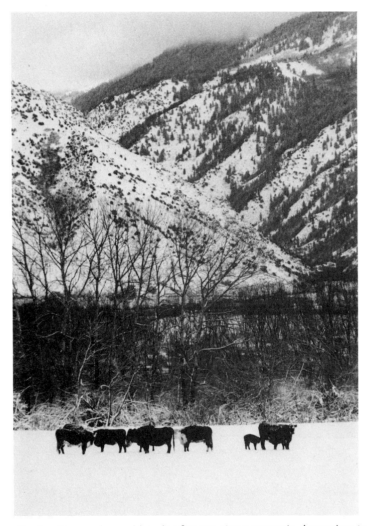

Contrasting angles and bands of tones give geometric dynamism to an otherwise static snow scene. Cattle add emphatic weight and color. Exposure determined by substitute reading from photographer's hand, plus one stop.

VARIETY

Another of my favorite compositional techniques is looking for variety in the picture area. If there is a group of shapes or areas of several sizes, I arrange the composition so that they all have different size relationships to each other. I look for ways to give purposeful variety to the visual shapes and lines within the photograph. I must admit, of course, that much of the time this "looking" is a spontaneous, unconscious reflex, but there are times when I look very deliberately for variety in relationships.

This fractured list of guidelines is by no means complete, nor is it meant to be a canon of sacred rules. Composition is an extremely subjective experience; it is always changing as a concept, and always growing as an ideal. It is to be hoped photographers will continually search for new ways to express old truths. Your compositional concepts will expand as you approach each subject and situation with fresh ideas and new eyes. Study the guidelines given here and apply them to all the pictures you see, comparing, thinking, and feeling. Then forget the particulars and reach deep inside yourself for those unique feelings and images that you, and only you, can create.

14

Low-Light Films and Developers

About films and developers there is much ado; so I will just mention briefly some of my favorites. You can choose your own; they are all good.

COLOR FILM

I have found color slide films such as Kodachrome 64, Ektachrome 200, and Ektachrome 400 to be the most useful color films. They are readily available and can be processed almost anywhere in the world and, more important to some photographers, they are acceptable for publications and for mixed-media productions. In most areas one-day processing is normal for Ektachrome, and sometimes for Kodachrome, as well. Ektachrome can be push-processed for that extra speed sometimes needed in low light. And it is no secret that slide films (transparencies) have the best color and finest grain of the color films. Don't forget that you can have prints made from slides.

Of course, color print film has its place too. And with the new ASA 400 films like Kodacolor, it is just a matter of choice as to which you want from the negative, slides or prints.

My favorite slide film is Kodachrome 64; it is fairly fast and has a warm color cast and unusually fine grain, al-

most as fine as that of Kodachrome 25, the fine-grain champ.

If you want super-fast color for extremes in low light, then pick up some Ektachrome 400 and plan on being amazed when you get the slides back. The grain is quite fine, but more surprising is the color rendition under low light. Usually, Ektachrome films tend to be bluish in low-light conditions, but this high-speed contender is almost as warm as Kodachrome 64.

Actually, most of today's films will perform very well in low light. Color-shift tendencies of various films were discussed in Chapter 8.

BLACK-AND-WHITE FILM

Any of the new ASA 400 black-and-white films would be a good choice. I would probably stick with Tri-X just out of habit, if it were not for the fine reusable cassettes that come with Ilford HP5. I have found no appreciable difference between Tri-X and HP5 as far as grain is concerned. However, there is one significant difference between the two films that would put HP5 way out front if I needed to push-process for an extra stop of film speed. HP5 is noticeably less contrasty than Tri-X. This means you can push-process HP5 one-half to one stop without a loss of shadow detail. In other words, you can use HP5 as though it had a normal ASA rating of 600 or 800 without losing anything in quality when compared with Tri-X. But I still like Tri-X—it is a hard film to beat.

There are several high-speed recording-and-surveillance films, such as Kodak Recording Pan 2485, 2484, and 2475. The fastest is 2485, which can be rated at ASA 8000. Although these films can be useful in critical situations where a photograph must be produced at all costs, they are awkward to handle and I do not recommend them

Shot on Plus-X film, this photograph has been printed to mural size without losing much of its crispness. Good lighting measured by an incident-light meter, plenty of clean contrast, and careful processing can give negatives that will produce mammoth prints.

for standard low-light use. ASA 400 films can be pushed a long way and will give you the images you want ninety-nine percent of the time, with a quality far superior to that of the recording films.

But go ahead and try them—you may like them. Just follow the directions that come with them (for example, they call for different developers when used at different speeds) or write to Eastman Kodak for more information. Just a hint: Where Kodak 857 developer is called for, try a standard high-speed developer like Acufine instead and cut the ASA rating to about 3000.

At the other extreme, do not throw away your old Panatomic-X film. Used with a tripod-steadied camera, this ASA 32 film will produce gigantic enlargements that will knock your eye out. I always carry a few rolls of Panatomic-X with me, just in case I happen on a subject that would look great enlarged to a mammoth size.

There are new films and developers cropping up every day, it seems; some revolutionary high-speed films and exotic developers will undoubtedly be produced in the near future. So hold onto your hat and take advantage of the high-speed ride.

PUSH-DEVELOPING BLACK-AND-WHITE FILM

Black-and-white developers are something of an enigma to me. I have tried most of them off and on and compared them from time to time. The exotic formulas do not seem to produce what I expect or want; so I have shrugged and returned to D-76, 1:1 (the stock solution diluted with an equal amount of water). With D-76, Tri-X or Ilford HP5 can be pushed to ASA 800 without noticeable loss of shadow detail or increase of grain. Occasionally I use D-23 for high-contrast subjects.

I hesitate to pass on my personal techniques because I have modified the factory-recommended procedure so much that it is nearly unrecognizable. Also, my procedure might not fit your situation without some changes of equipment, etc. But here it is, a simple, lazy person's approach to film development.

CONSTANT-AGITATION DEVELOPING SYSTEM

I have a Unicolor roller base adapted to work with stainless-steel tanks. The Uniroller reverses itself back and forth while turning, thus changing the flow of the developer so that uneven developing (causing streaking) does not occur. The Uniroller is connected to a standard Gra-Lab timer; so I can do something else until I hear the Uniroller stop. Using this system and a stainless-steel tank with a 237 ml (8 ounce) capacity, I can get by with only 118–148 ml (4–5 ounces) of developer—this saves chemicals and provides better agitation than a full tank. The procedure is as follows:

Tri-X ASA 800
D-76 (1:1) at 20 C (68 F)—roller-base agitation.
Agitate continuously for 24 minutes.
Stop, fix, and wash normally.

152

*Modified Uniroller agitates
a plastic drum holding a
stainless steel tank (any
size from 8 oz to 32 oz).*

Before I began using the roller base I used to process Tri-X in D-76, 1:1, for 13 minutes in a stainless-steel tank with the usual inversion agitation.

For those extremes-of-contrast situations such as encountered with stage lighting, I have found that super-compensating D-23, with a Kodalk solution as a second bath, works well. You will not believe the results obtainable with this amazing combination. Very contrasty subject matter can develop a full range of tones in the negatives and prints. Before you rush down to the photo store to buy this miracle developer, though, I'd better warn you that you cannot buy it already mixed; you buy the prepared chemicals and mix it yourself. Don't be put off; mixing this developer is a breeze. See the accompanying tables for the simple formula and mixing instructions. The developing procedure follows.

DEVELOPER D-23 MIXING DIRECTIONS

Begin with 71 ml (24 ounces) of water at approximately 49 C (120 F), using
 distilled or deionized water.
Add 5 ml (1 teaspoon) sodium sulfite.
Mix until dissolved.
Add 10 ml (2 teaspoons) Elon (or metol).
Mix until dissolved.
Add 60 ml (4 tablespoons) of sodium sulfite.
Mix until dissolved.
Add water to make 960 ml (32 ounces, or 1 quart) of working solution.

NOTE: Be sure that each spoonful is level with the top of the measuring spoon; use a knife or straightedge to make sure.

153

SECOND BATH (KODALK) FOR DEVELOPER D-23

Begin with 960 ml (32 ounces or 1 quart) of water—using distilled or deionized water.
Add 15 ml (1 tablespoon) Kodalk (or sodium metaborate).
Mix until dissolved.

NOTE: This is to be added directly after dumping the D-23 formula from the tank—do *not* rinse out the tank or use stop bath *before* this bath. Be sure to use a stop-bath solution *after* this bath.

Tri-X ASA 400, Plus-X ASA 125
D-23 and Kodalk at 20 C (68 F), continuous roller-base
 agitation.
6 minutes in D-23.
3 minutes in Kodalk (or sodium metaborate) solution.
Stop with acid stop bath; fix and wash normally.

One of my colleagues, a good friend, has come up with a super-push formula and system that together produce excellent negatives with fine grain and good tonal gradation. The developing procedure is as follows:

Tri-X ASA 1600
HC-110 Replenisher (1:15, syrup to water) 24 C (75 F).
3 minutes 10 seconds developing time (agitate roller-
 base continuously, or invert tank for first 15
 seconds, then invert once every 15 seconds).
2 minutes in water bath (fill tank with plain water or
 water mixed with a few drops of the used de-
 veloper solution). DO NOT AGITATE.
Stop, fix, and wash normally.

This same friend, who is a walking encyclopedia of photography, suggests using a postflashing technique to double the ASA rating of any film, whether color or black and white. The ingenuity of this system is that it increases the film speed without increasing contrast.

To use this system, you have to put your film in register with the camera's sprocket holes before you expose it. To accomplish this, cock the shutter, and place the film leader in the take-up spool so that the first double sprocket holes are engaged on the top sprocket gears (or you can make a mark on the camera next to the sprocket holes and on the film with a felt-tipped pen or soft lead pencil). Ro-

154

tate the take-up spool with your fingers to eliminate the slack.

This procedure, when repeated for postflashing, will permit fairly accurate registration—sufficient to make registration discrepancies unnoticeable when the slides are mounted.

After you have accurately made your registration markings in this way, set the ASA indicator to the next higher step; for example, change 64 to 125, or 400 to 800. Then shoot the film as you normally would. When you have finished the roll, be sure to mark the cassette with the new information. Just before the film is processed (within several days of exposing it) load the film back into the camera, using the registration marks to align the film exactly. Set the ASA dial to the same (adjusted) ASA indication. Set up an 18-percent-gray card to fill the viewfinder, but leave it out of focus. (A tripod will help here.) Now adjust the controls for three f-stops' underexposure and, using the largest possible aperture, shoot the whole roll of the out-of-focus gray card. Then have the film processed normally.

With this system you can even expose some frames normally and push some one stop. If you keep track of the numbers of the pushed frames, all you have to do is re-thread the film in register, postflash those frames (that is, shoot them of the gray card, as described), and process the film normally. You will then get some normal-ASA exposures and some pushed-ASA ones on the same roll.

There are a lot of film processing systems and other developers: Acufine and Ethol's ultra-fine-grain UFG are a couple more. My advice is to pick one developer and stay with it until you get the results you want. Do not jump around from one developer to another—most of the developers nowadays do a fine job. Just remember that there will be times when your negatives and slides will come out wrong, and you will not know why. Do not change film or

developers if this happens; keep at it until you find out what went wrong. Of course, be aware that there will be times when you will not be able to find an answer.

Do not be discouraged to learn that photography is less than an exact science in which everything is predictable and complete. The knowledge of this brings me a mixture of despair and excitement; yet too much preconceived precision destroys the quality of photography that I enjoy the most—discovery. I suppose that all of us who carry cameras should seek the best of both certainty and uncertainty, make the most of the paradox. Even the great father of the yellow boxes, Eastman Kodak, philosophically sums it up in one word at the top of the pink instruction bulletins that come with new products or processes: *Tentative.* KEEP TRYING.

Marks made on the camera body and on the film leader will line up the film for near-perfect registration when the film is reloaded for postflashing, as described in this chapter. Be sure the shutter is fully cocked before you line up the marks.

Appendix

Metric Conversion Information

When You Know	Multiply by	To Find
inches (in.)	25.4	millimetres (mm)
feet (ft.)	0.3048	metres (m)
miles (mi.)	1.609	kilometres (km)
ounces (oz.)	28.349	grams (g)
pounds (lbs.)	0.453	kilograms (kg)
pounds per square inch (psi.)	0.0703	kilograms per square centimetre (kg/sqcm)
cubic feet (cu. ft.)	0.0283	cubic meters
Fahrenheit temperature (F)	0.5556 after subtracting 32	Celsius temperature (C)
fluid ounce (oz.)	29.57	millilitres (ml)
quart (qt.) (U.S.)	.9472	litre (l)

ASA AND DIN FILM SPEEDS

ASA	DIN	ASA	DIN	ASA	DIN	ASA	DIN
6	9	25	15	100	21	400	27
8	10	32	16	125	22	500	28
10	11	40	17	160	23	640	29
12	12	50	18	200	24	800	30
16	13	64	19	250	25	1000	31
20	14	80	20	320	26	1250	32

Tables and Diagrams

Index

159